New Mexico's Crypto-Jews

New Mexico's Crypto-Jews
Image and Memory

Photographs by **Cary Herz**

INTRODUCTION BY ORI Z. SOLTES

AFTERWORD BY MONA HERNANDEZ

UNIVERSITY OF NEW MEXICO PRESS ❧ ALBUQUERQUE

© 2007 by the University of New Mexico Press

Photographs © 2007 by Cary Herz

All rights reserved. Published 2007

Printed and bound in China by Everbest Printing Company Ltd. through Four
Colour Imports, Ltd.

13 12 11 10 09 08 07 1 2 3 4 5 6 7

All quotes from subjects are taken from interviews and
personal correspondence from 1988 to 2007.

Library of Congress Cataloging-in-Publication Data

Herz, Cary.

New Mexico's Crypto-Jews : image and memory / photographs by Cary Herz;
introduction by Ori Z. Soltes ; afterword by Mona Hernandez.

p. cm.

Includes bibliographical references.

ISBN 978-0-8263-4289-8 (cloth : alk. paper)

1. Crypto-Jews—New Mexico—Pictorial works.

2. Jews—New Mexico—Pictorial works.

3. Crypto-Jews—New Mexico—History.

4. Jews—New Mexico—History.

5. Hispanic Americans—New Mexico—Pictorial works.

6. Hispanic Americans—New Mexico—History.

I. Title.

F805.J4H47 2007

978.9´004924046—dc22

2007019175

Design and composition: Melissa Tandysh

Images: HALF TITLE, Our Lady of Guadalupe,
San Antonio, Texas

FRONTISPIECE, Seville, Spain

PAGE iv, Guadalupe County Ritual Slaughter

PAGE xviii, The Five Commandments

PAGE xxii, Statue of Mary, Rio Arriba County

PAGE 147, Church Steeple, Rio Arriba County

To my parents,

Fred and Gertrud Herz,

and brother, Leonard Alan.

To my great aunts

Augusta, Lina, and Sophie Herz,

who perished in Auschwitz.

And to those we remember

who have died because of

religious and ethnic cleansing.

CONTENTS

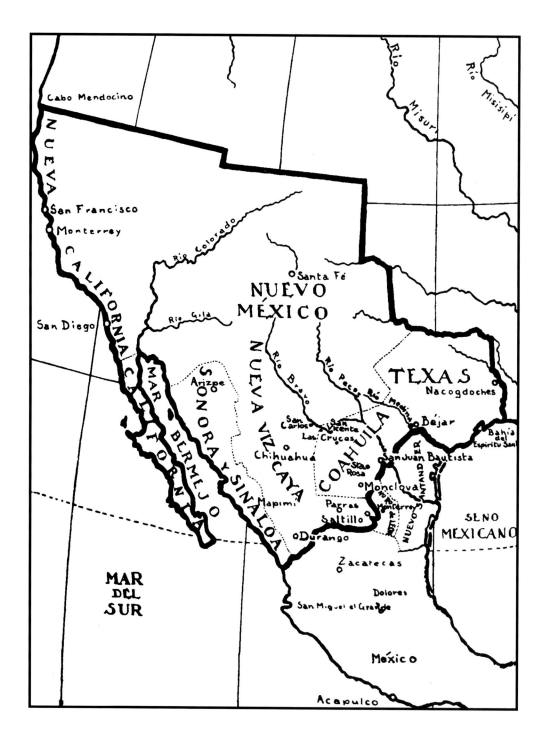

The Provincias Internas of New Spain. From Fray Juan Agustín de Morfi, *Viaje de indios y diario del Nuevo México*, ed. Vito Alessio Robles, 2d ed. (México, D.F., Antigua Libreria Robredo de José Porrúa e Hijos, 1935), frontispiece.

While I was photographing the Congregation Montefiore Cemetery (the Jewish cemetery) in Las Vegas, New Mexico, in 1985, I heard whispers of "What about the other people?" The other people were those who had immigrated to Mexican territories and were Hispanic Catholics on the outside and Jewish on the inside. (This was a different migration than the one made up of German and other eastern Europeans, who arrived in the late nineteenth and early twentieth centuries and were eventually buried in the cemetery in Las Vegas.) This marked the beginning of my twenty-year odyssey in search of symbols that might

indicate the presence of descendants of Sephardic Jews, those forced to convert to the Catholic faith during the Spanish and Portuguese Inquisitions. Some of these New Christians, or *conversos*, despite professing Catholicism openly, continued to practice their ancestral Jewish faith in secret. These crypto-Jews, or secret Jews, were descendants of conversos who came to Nueva España (New Spain), now Mexico and its former territories, in the sixteenth, seventeenth, and eighteenth centuries. They came to Nueva España and then north to New Mexico with the conquistadores, Hernán Cortés, Luis de Carvajal y de la

Cueva, Gaspar Castaño de Sosa, and Juan de Oñate.

The images in this book honor the descendants of the hidden Jews, those related to the original immigrants who secretly held on to Jewish religious beliefs, customs, and language in some fashion for over five hundred years. Some were able to do this despite threats of persecution, ostracism, punishment, or even death from the Spanish, Portuguese, and Mexican Inquisitors. Among my subjects are those who knew about their Jewish pasts through family oral history and practice, those who have only recently become interested in exploring their families' customs and practices, and those who knew nothing about their ancestry and are only now beginning to examine their possible Jewish heritage.

There has been intense debate among some scholars over evidence of the New Mexico's crypto-Jews. Some people have doubted the veracity of descendants' oral histories and genealogical documentation. However, I am not writing a history of the descendants of the crypto-Jews. This is a photographic diary of the people I have met and what they know about their families. What they know about their history is vast, whether from strong oral traditions and customs, DNA results, or their own search for their pasts. Their commitment to their hidden roots should not be taken lightly. (For further information please avail yourself of the books and articles listed in the bibliography.)

Here are some anecdotes from the history of those hidden Jews who came to the New World looking for freedom and survival.*

In 1492 King Ferdinand and Queen Isabella issued the Edict of Expulsion, which decreed that all Jews had to leave the Iberian Peninsula or convert to the Catholic faith. The Jews went primarily to Portugal and the Ottoman Empire, but many also went to France and Italy, and later Holland, England, and the New World. Those who did not leave were forced to convert, and they became the New Christians, the conversos. Many converted sincerely, while others secretly held on to their ancestral faith.

When Hernán Cortés landed on the coast of the American mainland in 1519, several conversos accompanied him. In Nueva España, conversos were at times severely punished if they were found to be secretly practicing Judaism. In 1571 Spain established a formal Tribunal of the Inquisition in Mexico City, which accelerated the persecution of crypto-Jews. During the colonial period, especially during two campaigns in the 1580s–90s and

* A bibliography of sources about the Sephardic Jews in the New World and other related topics appears at the end of the book, along with a glossary of unfamiliar Spanish and Hebrew words.

the 1640s, about fifteen hundred people were convicted of being "Judaizers," meaning they observed the Laws of Moses and followed Jewish practices. Punishment was severe. Judaizers were forced to spend time in prison. Some lost all their status and possessions, and a small number were burned at the stake.

Ironically, almost all information about Jewish settlements in Mexico during the colonial period is based on documents produced by the Inquisition authorities, whose investigators took great care to record every piece of testimony and every bit of evidence they extracted from those suspected of secretly practicing Judaism. In their zeal to eliminate Judaism from Mexico and all the territories controlled by Spain, they kept meticulous notes that are invaluable to today's historians and descendants.

Many stories exist about the conversos and hidden Jews who traveled north away from Mexico City, fleeing persecution. Many moved first into the province of Nuevo León, a northern territory of what is now Mexico. Luis de Carvajal, the grandson of Portuguese New Christians, became the first governor of that province around 1579. He was arrested and sentenced by the Mexican Inquisition on February 23, 1590. He disavowed his Jewish faith and was said to have shown sorrow for his sins. He died later that year in prison.

Gaspar Castaño de Sosa, Carvajal's lieutenant governor, was also Portuguese by birth. In 1590 he led an unauthorized expedition up the Rio Pecos to establish a colony in New Mexico. Historians believe that many people of this expedition were conversos, and that they were running from the Inquisition's investigators. Troops were sent north to bring the expedition back. Castaño was arrested for treason, convicted, and exiled to the Philippines.

In 1598 Juan de Oñate established the first European colony in the province of New Mexico. Oñate recruited many of Castaño's followers. With him were some survivors of the Castaño expedition as well as individuals whose names have turned up in the Inquisition records in Mexico City. Oñate traveled north along the Rio Grande and established his colony near San Juan Pueblo, close to what is now Española, New Mexico.

Inquisition records show that several families, including the Gómez, Griego, Jorge, and López de Mendizábal families, were found to have been practicing Judaism. Some were arrested and taken to Mexico City for trial. For example, Francisco Gómez Robledo was arrested in Santa Fe in 1663. He was known to be of Portuguese Jewish ancestry. He and his brothers were determined to have been circumcised—a telltale sign of Judaism. He was acquitted, however, and his descendants can be found among New Mexican Hispanics to this day.

Many Jews who converted to Catholicism under duress were not in official positions and quietly blended into their communities in Mexico, New Mexico, and other areas of

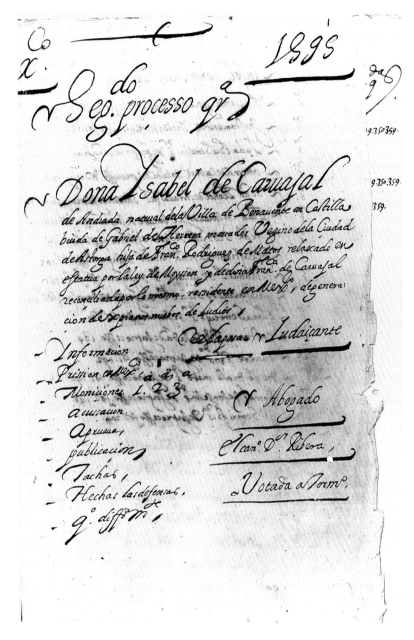

Doña Isabel de Carvajal, 1595 documents from an Inquisition trial in Mexico City. Courtesy of The Bancroft Library, University of California, BANC 96/95 m. vol. 4.

what is now the southwestern United States. Through the centuries they have assimilated into the local Hispanic culture. Despite the fact that descendants of the conversos were practicing Catholics or Protestants, memories and family stories remained. Some families maintained their commitment to Judaism and clung to each other in recognition of their hidden faith. According to descendants, some families recognized one another by their surnames, names that had to be changed when their families converted. Some of the names include Coca, Gómez, Leyba, Medina, Salas, Silva, Rael (from Israel), and Vigil (Vixil), with certain exceptions. No scholarly evidence links certain names to crypto-Jews, but stories among the converso community provide circumstantial evidence.

The story goes that New Christians often took their new names from the natural world, like Montaño (mountain), Peña (rock), Pino (pine), Flores (flowers), and Rios (rivers). Some New Mexican Hispanics know nothing about their ancestry except that they were originally from Spain, but their ancestors continued using Old Testament first names such as Moises, Rebecca, Isaac, Solomon, and Adonay (*Adonai*, the Hebrew word for God). These are hints that can be starting points for conducting investigations into a family's origins.

Some New Mexican Hispanics have been guided by a "feeling" about their ancestors and have started their own personal journeys of discovery. Sometimes these journeys entail

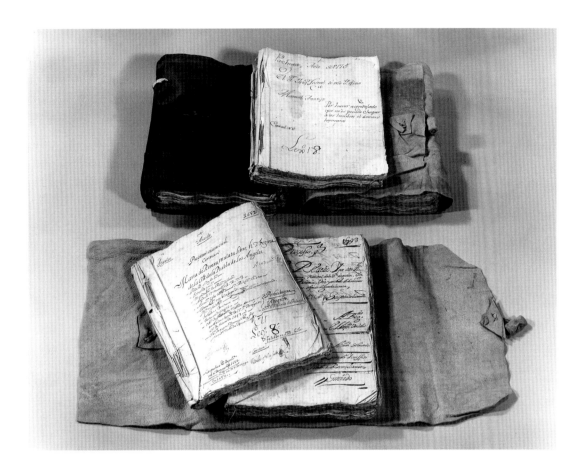

The Carvajal family's Inquisition records from Mexico City. Courtesy of The Bancroft Library, University of California, BANC, MSS 96/95 m. vol. 7.

going to the New Mexico State Records Center and Archives in Santa Fe, or to the archives in Mexico City. Some have traveled to look at the archives in the large cities of Spain and Portugal, or the libraries and archives in the small towns that dot the Portuguese-Spanish border. Some have talked with elder relatives, to confirm their childhood memories, or to find out more about the lives of their grandparents. Some have looked for Sephardic links through DNA testing, tracking the male Y chromosome. Finding a Sephardic link often encourages people to do more research. Recently, as part of a DNA project, Maria Apodaca (page 26) discovered that eleven generations back, in the 1600s, her family could be traced to Semitic origins on her maternal grandmother's father's side.

Some individuals remember unusual family customs and practices that they didn't

recognize as part of the traditional Jewish way of life: mirrors being covered when someone died; a grandmother with a small scarf over her head in a secret room lighting candles on Friday night; the practice of male circumcision; or slaughtering beef and lamb in the kosher fashion by hanging the animal upside down, slitting its throat, and letting the blood drain on the ground (since the consumption

of the animal's blood is forbidden by Jewish custom). Others played with a *trompito*, or *pon y saca*, a top similar to a Jewish dreidel.

Some others have heard the whispers of "*Somos judíos*" (We are Jews) from the old ones in the family. After five hundred years of secrecy and fear, descendants of the *Anusim* (meaning "forced ones" in Hebrew) are choosing to come out of the shadows. They are investigating their family histories and their own inner souls. Unlocking their past has freed many to join Jewish communities. Others have joined different faiths, like Protestantism, or have remained Roman Catholic. For others, a Christian-Judeo hybrid culture has taken root, meaning they practice both religions but are not Messianic Jews. Many feel that if their ancient religion is in their hearts, then no more "proof" is necessary.

Emilio Coca speaks about a *pon y saca* (or *trompito*), a toy very similar to the Jewish dreidel, made by his grandfather. The family used it when he was a child. He has several others, along with his grandfather's kosher knife.

My search has led me down many of New Mexico's back roads. The result of my odyssey is a photography book, not a history book. It tells a story about the present and about how the past continues to live in the present. What is it like to grow up knowing that your family has a secret, or to find out later in life from some relative that your family kept such a secret even from you? How would we think of ourselves with this new information? What would change for us? This book is a photographic journal of people's discoveries—not only of their families, but of themselves. Art should not give the answers. It only poses the

questions. The viewer should find his or her own answer.

In my thirty-five years as a photojournalist, I have always been interested in people: how we live, what we think and feel, and what we look like. I have always felt that a universal human connection binds us. Why have I spent so much of my life seeking "the hidden ones"? It has to do with my relationship to my subjects—behind the camera, I have been able to remain hidden. Yet it is because I feel hidden, protected, that I have been able to approach my subjects. The sense of confrontation, of meddling, of simply putting myself out there, has been canceled out by my sense of concealment, and of safety, behind the lens.

Learning about the crypto-Jews of New Mexico has allowed me to ask questions about my own history, has brought me closer to my family's past, and has given me new insight into myself. I have visited Steinheim am Main, a small town near Frankfurt, Germany, where my father's family resided since the 1600s, and explored Vienna, Austria, where my mother grew up.

My parents, too, were forced to leave their countries and change their language. They had to leave behind their way of life, people, and places they knew and loved. They tried to recreate a semblance of their past in New York City, and at the same time they wanted to fit in and not be identified as "different." As a Jewish woman with European roots, I understand the fear and complexity of being different from everyone else—wanting to be the same while silently cherishing my differences.

My connection with the descendants of those who survived the Inquisition has to do with my own past. As I get older I feel more keenly my own "memories" of many things about which I do not have all the facts. I am a child of refugees from the Holocaust. Neither my parents nor my extended family spoke much about how their lives were affected by the Holocaust, but of course they were drastically and irrevocably changed. My parents experienced fear, flight, secrecy, poverty, and luck in their late teens and early twenties. In 1939 my father Fred Herz was sent to Dachau, the concentration camp outside of Munich. When he was released several months later, he had to report to the Gestapo every week until he was lucky enough to be able to sail to England. My mother Gertrud Weinreb, her younger sister Stella, and their parents Henry (Chaim) and Rose lived under the Nazi occupation of Austria. They left Vienna at the last minute—but not until my mother managed to secure her father's release from an Austrian prison. They moved through three countries until they arrived in the United States. Along the way, my grandfather was also in a French jail outside of Paris. My grandmother saved him from that prison, but no one in the family knew how she secured his release. They came separately to New York City, arriving in late 1939 and 1940. I don't know how long all this

took because they would not share a lot of details. They would only say, "It was not for that long." From the Anschluss, annexation of Austria by the Nazis (March 1938), to Kristall Nacht in Berlin (November 1938) and the earlier Nazi control of Germany sounds like a very long time to me.

I have all the documents from their ordeal. They saved everything they could, including the numbered armbands my father wore in Dachau. It must have meant everything to them to carry all those mementos of their mental and physical pain. This is not an unusual story. It is the story I grew up with. My family was determined not to pass their pain on to my brother and me. They created a full life for us. They had high ethical standards. They cherished learning, great food, family, vacationing in the Catskill Mountains, and they did not like looking back at the sorrow of their past. They put a good face on the situation. Still, they couldn't help but share what had happened to them and millions of others. It was a hard time for them. As individuals, my parents did the best they could with the situation at hand. They knew they were lucky to have reached America to start anew. They were very proud to be Americans and Jewish. They did not think of themselves as victims.

I am not a sociologist or a historian; I am a photographer. I have created a photographic diary of individuals who have a hidden past that they question, embrace, and treasure. This book is about their discoveries and not my own. It is my way to tell some of their stories, to witness their history. My goal is to put a face on the invisible ones, the Anusim, to open a small window into their world, to show their pride and diversity.

The crypto-Jews are catching up with their past, a past that has not been erased but is incomplete. By acknowledging their complex history and speaking out, they become a visible tribute to the ordeals and courage of those ancestors who were forced into secrecy and silence. It is my hope that this book will be supportive to those who are beginning to acknowledge their histories and their identities, that it will help them stand up and be seen as those "other people" who needed to be hidden for so long.

Cary Herz
Albuquerque, New Mexico

Easter, San Felipe de Neri,
Albuquerque, New Mexico,
April 4, 1994

Some churchgoers from the
Old Town neighborhood where
the San Felipe de Neri Church is
located claim the two six-pointed
stars above the altar are repre-
sentative of their Jewish ancestry.
An older photograph from 1903,
available from the Albuquerque
Museum archives, shows the six-
pointed stars without the Sacred
Heart in the middle.

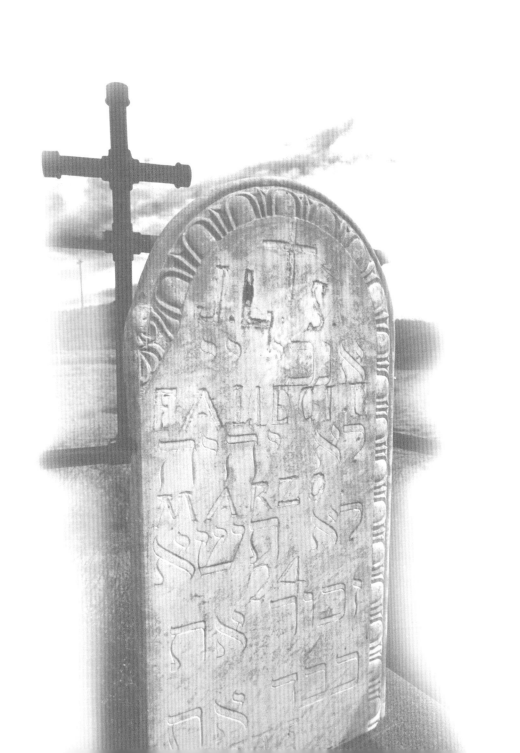

Some of these photographs have appeared previously alongside newspaper and magazine articles in the United States, Israel, Switzerland, and New Mexico. They have also appeared in exhibitions in the United States and Mexico. This is the first time the images of this long-term project can be seen as a whole. I have always envisioned this collection of photos as a photography book that could be viewed and pondered.

I would like to acknowledge, with much gratitude, the many people who encouraged and helped me so that this book could finally be completed.

I want to express my deep gratitude to all the people who have given of themselves and have allowed me to photograph them. Along with their families' stories, they shared their kindness and trust, which made this book possible.

I would like to thank Dr. Stanley Hordes, who always reminded me to check the facts and looked over my writing on the history of the settlers in New Spain. He and Gerald González traveled the roads along the Portuguese-Spanish border in 2000. I joined them as they researched families from New Mexico in the border

towns' archives. I thank them both for that fun adventure.

Ana Pacheco, publisher of *La Herencia* magazine, and *Hadassah Magazine* published several photo essays in 1990 and 2004. Their interest kept me motivated at times when I was close to ending the project.

Rabbi Min Kantrowitz and Diane Palley advised me on Hebrew translations and understanding the Ten Commandments. Jo Roybal Izay advised me on Spanish translations. I thank them all for their guidance.

My deepest appreciation goes to Enid Howarth, a great friend, mentor, and editor. She talked me through more insecurity than I wish to discuss. Her knowledge of language helped my ideas flow. Sue LeGrand, another person with a great understanding of language, edited the captions and stories. I thank them both so much for their friendship, expertise, and editing skills.

I am grateful for the editing assistance of Davielle Lakind and Sally Bergen who both looked over my early writings and directed my attention to new ideas.

I am indebted to Ori Soltes, who was willing to just jump in and write his beautiful Introduction. His knowledge of art, history, photography, and religion resulted in a piece that grasps the spirit of the crypto-Jews. I thank him very much for his perspective on the subject and my work.

Kathleen Teltsch, reporting for the *New York Times*, wrote two articles about crypto-Jews for her newspaper. Her writing made the subject engaging and understandable for readers. My photographs were used in those articles. In 1994 Kitty and I traveled together to Portugal to meet New Mexico descendants visiting with crypto-Jews in the village of Belmonte, along the Spanish border. Denise Kusel, writer, editor, and columnist for the *Santa Fe New Mexican*, lent a hand setting up lights at one shoot and helped write some of the early interviews. She also published several photographs from the project, along with the articles that ran in *Pasatiempo*.

I would like to thank my friends Ben Daitz and Mary Lance, who introduced me to Luther Wilson at the University of New Mexico Press. Luther was interested in my book and supported it through all its approval processes and editing. He has been wonderful to work with. Managing editor, Maya Allen-Gallegos, and senior book designer, Melissa Tandysh, both added greatly to this book as you will see. Their skill and experience contributed immeasurably. I thank them both.

Special thanks goes to Mona Hernandez for sharing her research about her ancestors, the Gómez Robledo family. This family started a confraternity in honor of La Conquistadora, Our Lady of the Rosary, who now resides in the Cathedral in Santa Fe.

A second thank you to my partner Sue LeGrand for her support and love.

Art, History, Memory, Identity, Truth:
The Art and Craft of Cary Herz

Ori Z. Soltes

ONE: Photography as History,
 Truth, Craft, and Art

The camera began to develop as a two-pronged instrument in the second quarter of the nineteenth century. Two cognate scientific realizations began to emerge in the 1830s: a new understanding of how light works (that it is ultimately a rainbow array of colors, and that at both ends of the spectrum are colors that fall off the range of what the human eye can deduct—infrared at one end, ultraviolet at the other) and of how the eye sees. One of the consequences of these scientific realizations for some painters was a shift in how they defined their visual goals. The Impressionists were less interested in producing works that offered to the viewer the illusion of looking through a window into real space; they were more ready and willing to engage the viewer as a partner in completing the painting. This they accomplished by allowing the evidence of the artist's presence—the imprint of the brush and sometimes even the hairs from the brushes left embedded in the pigment—so that to complete the traditional illusion viewers would have to define their own, individualized viewpoint, which would change depending upon the shape and strength of

individual eye pupils. Moreover, in the long run Monet in particular, but also Pissarro, Renoir, Sisley, and others, were less interested in recording the configuration and placement of the objects they depicted than in suggesting how objects had no absolute configuration. How we see them is constantly shaped because of shifts in the light and shadow that in the course of a day or a season move over them. In fact, one might say that these painters were interested in dissecting and reconstructing light itself, and not the objects the seeing of which is facilitated by light.

This development in painting was in some respects a double response to the development of photography that paralleled the developments in spectroscopy and the science of seeing. Not only did the matter of light offer a new subject and a new object for visual consideration, but the fact that the emerging technology of the camera made it possible to record with absolute precision a given object or place at a given moment in time seemed to some to undercut the validity of trying to accomplish that feat with a paintbrush. So the first prong of the camera as an instrument was simply to record with visual precision. If over the next 170 years painting waged a continuous battle with itself regarding what it ought to be and do—swinging between impressionist sketchiness and photorealist finish, from millimeter-by-millimeter precise figurative representation to coloristic and formal abstraction—so, too,

photography soon began to recognize within itself a second prong of multiple possibilities beyond that of historical record-keeping. Photography could—and did—offer a range of artistic imagery as rich as that afforded by painting (thus reversing the assertion that painting, in the right hands, could offer as precise a record as could photography).

The basic technology of photography is simple enough. The name "camera" comes from the Italian word for "room," and in fact offers only half of the complete phrase that would do what names in so many traditions are thought to do: describe concisely what a camera *is*. *Camera oscura*—"dark room"—refers to the fact that a camera is a small box (a tiny room) filled with darkness into which a pinpoint of light is introduced for a prescribed piece of time. That point of light, interacting with paper, chemicals—and more complexly, at times, a lens or series of lenses—yields the image projected into the box from the world outside it. But the image is ghostly, white and black, negative, until other chemicals reverse it and, on other paper, create a positive, black and white, full-fledged image (or as the case might be, and the chemicals on the paper within and beyond the camera, a color one). That reversal takes place in another camera oscura: the full-sized darkroom where the photographer manipulates the paper and chemicals that yield the positive image.

Thus the camera's eye records the world as it is and reverses it; and later, in the darkroom,

the reversal is reversed to produce the record of how the world outside the box is. The double process is scientific, but also magical. Stripped of the terminology of chemical formulae and the accompanying discussion of what causes the changes in and on the paper on which the images ultimately appear, the process suggests something supernatural; the practitioner thereby exercising a skill associated in earlier eras with priests and prophets. Like them, the photographer stands on the border between the world of the everyday and that which is beyond our reality.

Given the necessity for manipulation of paper, light, and chemicals, it was only a matter of time before photographers would and did come to realize that they could inject themselves into the inner depths of the border process, thereby creating art and not just a straightforward record of history. Both the camera-operator and the film developer, instead of merely capturing life as it is, can alter the vision of it to capture it as it really is not. When this is done without informing the viewer, the product is a deliberate lie (as when the Nazis manipulated the images of their victims to present them to the world as smiling rather than suffering; or when Stalin's photographic technicians eliminated the image of this participant or that from the larger image of this conference or congress or that—thereby also attempting to eliminate them from history). Thus, ironically enough, the medium that purports to offer visual facts

in a way no painter can, can distort the facts and instead present the viewer with nothing but falsehoods.

Conversely, it can offer truths that extend beyond mere facticity. When manipulation is done so that the viewer is aware of the process of transformation, the product is art: that which uses the artist's mind and eye as a sieve through which to re-vision reality. And such art can engage truth just as painting can. There is more: the very capturing of a moment—an action or a state that suddenly manifested itself, not before that moment and never again afterward—is itself an artistic act. The mind and eye of the artist, who captures on film a moment that others would have missed, or a juxtaposition of objects that others would not have noticed, yield art. For part of what art does is to move viewers—however gently or forcefully—to think in ways that they might not have without the work of art before them. In part, the photographer's art is being at the right place at the right time; in part it is being prepared to capture the right moment in that place and time and being open to that moment. In part it is simply seeing the moment—and preserving it for others forever after.

TWO: History and the Art and Craft
 of Cary Herz's Photography
Cary Herz falls perfectly into the broad and richly hued category of photographers who are both simple recorders of objects and events

and of artists who recognize and capture moments that offer an intriguing re-vision of captivating aspects of the human legacy, and who ask us to think about those re-visions and the varied layers of their significance. Her straightforward study of the culture, memory, and cultural and religious memory of the descendants of crypto-Jews in New Mexico is a compelling exploration of the relationship between the camera's power and the eloquence of people, places, and objects. Her art is the art of seeking not the truth of facts upon which everyone necessarily agrees, but the truth found in the sense of self emerging from the "seed of the past [that] all of us [as a species] have used in different ways to define ourselves in the twentieth and twenty-first centuries."*

This particular body of her work is profoundly appropriate to the condition of being—as an artist and a practitioner of both the science and, more, the *magic* of photography—a creature at the border between realms. For the community that she has captured and preserved is itself a border community: between its roots in Catholicism and its deeper roots in Judaism; between its connections to the Native American world and varied parts of the Euro-American world. The individuals and objects and places Herz has photographed all derive from a community that has been ostensibly Catholic in religion and Spanish in ethnic origin for many generations. But it is a community in which unusual customs also have a history for many generations—such as the kindling of candles on Friday evenings in candlesticks hidden away during the week or candles allowed to burn down through the evening, their candleholders restored to their hiding places after sunset Saturday.

The realization began to emerge in the early 1990s that such a custom bears a strong resemblance to the Jewish custom of kindling the lights on the Sabbath eve—at sunset on Friday—and that other allied customs, such as taking out a goblet hidden in a closet and filling it with wine on Friday evening, also suggest a link to Judaism. With the intensified focus on the Sephardic Diaspora occasioned by the quincentennial in 1992 not only of Columbus's first voyage, but also of the expulsion of Jews from Spain enacted by Ferdinand and Isabella (and in turn the quincentennial of the expulsion from Portugal in 1496–97), an obvious question presented itself to outside historians: could part of that double Diaspora have ultimately led into the northernmost parts of New Spain, from Mexico to New Mexico? To inside historians and keepers

* All Cary Herz quotes come either from an autobiographical statement written by her for the 1999 exhibition "Jewish Artists: On the Edge" or from a memoir sent to me by her in July 2006. All paraphrases come from conversations with Ms. Herz in spring 1999 and summer 2006.

of family traditions, that fascinating possibility took shape, and upon further examination, viewed as probability, and then for some, as certainty. The Sephardic Diaspora into this corner of the world carried with it a piece of a complex history, part of the complex history of the Jewish people in its infinitely varied border presence and passage.

Thus a century before the expulsion from Spain—in the atmosphere of ongoing attacks on Jewish communities that defined the period 1391–1415—large numbers of Spanish Jews ostensibly embraced Catholicism in order to survive, while maintaining their Judaism in secret. Their double lives served body and soul from the outside and the inside. But three epilogues to the story of crypto-Judaism played out in the generations—and eventual centuries—that followed the period of mass conversions. One is that by the decades leading up to the expulsion of 1492, the Spanish Christian authorities (the Inquisition authorities) whose role it was to investigate into matters of proper, nonheretical faith, as their offices became increasingly centralized began to focus with growing intensity on *Nuevos Cristianos* (New Christians). *All* of these were suspected of being crypto-Jews; thus increasing numbers of both Jews and crypto-Jews fled Spain for elsewhere.

The second epilogue is that many crypto-Jews who fled Spain before 1492 as well as those who, together with openly professing Jews, left at the time of the Expulsion, found themselves in places where now, if they chose to, they could return openly to their Judaism, and many did (including many who had genuinely embraced the Church, but now left it in dismay and disgust). But this return could prove to be complicated. Should the place where they took refuge, beyond the reach of the Inquisition at the time of refuge, come within the inquisitional reach, they might once again be in danger of prosecution, torture, and death as heretics. Thus, for example, the eastern coast of South America, in Dutch hands for years, fell under Portuguese control in 1654, after a nine-year-long war between the Netherlands and Portugal. With the Portuguese came the Inquisition that had long before reached beyond Spain into the kingdom of her neighbor and thus her colonies. Jews who had once been crypto-Jews and therefore ostensive Christians, having taken refuge in Dutch territory, now subject once more to the Inquisition, fled again. Similarly, when the Inquisition became firmly embedded in Mexico City and the territories of New Spain around it—and directed itself not only toward crypto-Jews, but toward Native Americans who, converted by force or choice to the loving bosom of the Church, still secretly practiced rituals from their centuries-old traditions— many fled its outstretched fingers to the northwestern corners of those territories where a degree of religious safety might be hoped for.

The third epilogue to this layered narrative is that, even at that distance from the center,

crypto-Jews on the periphery of New Spain still felt insecure and therefore remained more hidden than open as Jews. Moreover, they were not only on the periphery of the Spanish Catholic world, but of the dispersed Jewish world as well: a diaspora within the Sephardic Diaspora within the Jewish Diaspora. As such, as generation after generation led to century after century, their memory of Jewish customs and traditions became increasingly truncated. The keeping of the Sabbath, reduced to the kindling and blessing of lights and the benediction over wine, became further reduced, over time, to the kindling of lights and the pouring of wine without benediction or clearly understood raison d'être. Thus it could evolve that a Catholic family with genealogical roots in both the Old and the New Worlds might not realize that its unusual Friday night practices were not merely a peculiarity passed down from a great-great-grandmother, but the last thread in the rope connecting the family to Jewish ancestors who dwelled in Spain or Portugal half a millennium earlier. But the broad-ranging discussions and debates regarding the Sephardim occasioned by the quincentennial changed that: not only might such families come forth to be counted within the endlessly varied world of Jewry, but join in the genealogical inquiry into themselves that might or might not corroborate that demographic twist to their corner of the world at large.

This is the world with which Cary Herz's life as a photographer—as both a journalistic recorder of events and an artist—began to become intertwined by the mid-1980s. It is a world whose inhabitants are aware or have become aware of many more threads connecting them to their ancestors' Judaism—and in many cases, reconnecting them, after a lifetime of feeling disconnected from their innermost selves—than just those of candlesticks and wine goblets. There has been a range of ways in which the inhabitants of that world remember their connection to Judaism—from actions to objects to places; from circumcision and kosher-style slaughtering to candlesticks and works of carved art by a grandfather that were identifiably (and to other members of the family, uncomfortably) Jewish in intention; to the placement in the house of a windowless room where prayers were recited by a parent or grandparent in secret, morning and evening.

So, too, the response to the reawakening and reenergizing of that memory has varied, from the conscious inclusion of symbols identified by the carver as specifically Jewish in his woodwork, to repeated visits to the synagogue, to the decision to convert—back—formally to Judaism, to the decision to follow that decision with study for becoming Bar Mitzvah. The response has extended from the beginning of life to its endpoint in death and whatever lies beyond death, and to the ongoing memory of the deceased carried forward from one generation to the next.

Herz's series of crypto-Jewish people and

burial sites is a visual parable of the struggle for and against self-assertion that has marked Judaism historically and is present among even the most apparently free-to-express-its identity Jewish community the diaspora has ever known, the American Jewish community. New Mexico's crypto-Jews may be seen as a more direct and emphatic symbol of every nuance and pathway undertaken by American Jews of all sorts of backgrounds to undermine the forthrightness of their declaration of Jewish identity. But the details of this particular narrative within the larger Jewish story are more complex, still. In the bare decade since the "discovery" of New Mexico's crypto-Jews, at least one scholar has come forth to argue that these are, in fact, false crypto-Jews—crypto-crypto-Jews—who took on the guise of crypto-Judaism at the end of the nineteenth and beginning of the twentieth century (for reasons that fall outside this discussion).

Thus, for instance, a gravestone bearing the first five commandments of the Decalogue, in Hebrew, may have been removed from a synagogue where the other half of the stone may still be seen, and not created originally as a gravestone. But that it was chosen to serve as a gravestone, to yield evidence of the Jewish part of its heritage for the family of the deceased, seems more the point in this narrative of identity on the edge, than the question of how, specifically, it was crafted. More to the point, gravestones marked by crosses inscribed with or flanked by Stars of David suggest a dynamic wrestling between interwoven identities carried beyond the here and now into the indefinable thereafter.

THREE: *Tikkun* (Repair) and *T'shuvah* (Return) of Community and Self

Whether such images represent true crypto-Jews, descended from refugees from Spain and Portugal, or whether they reflect a more recent form of false crypto-Judaism, they signify, in their marvelous, multiple ambiguities, the boundary between individual and group and the edge between true and false knowledge of one's roots, as well as between memory and forgetting. The more so the depictions of the living people, who dwell scattered beyond the boundaries of cemeteries and their stones. Evocative images, such as that of Isabelle Medina Sandoval, poet and teacher, wrapped in her shawl and meditating in the snow-bound woods of a winter afternoon; and that of Lorenzo Dominguez (Levi ben Macario), radio producer, wrapped in his *tallit* and praying by the Rio Grande on a summer morning; speak eloquently of the borders between realities: self and community, present and past, this world and the world of the Other—and further, still, the one depicted by the camera oscura and the unseen other who *holds* the camera.

So do images like that of Perry Peña, holding his grandfather's candleholder and incense burner, carved with six-pointed stars. Whether they were intended by the

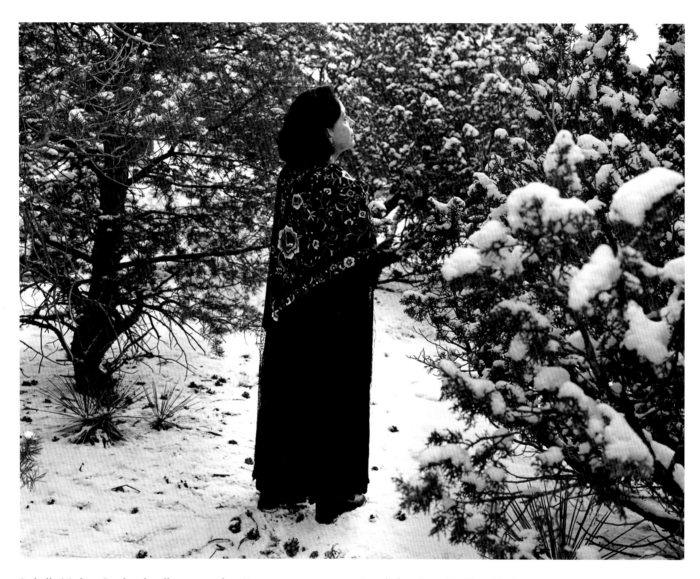

Isabelle Medina Sandoval walks among the piñon trees on a snowy winter's day, Santa Fe, New Mexico, 1999

grandfather as Jewish Stars of David is less relevant than that they are evocative for the grandson of such symbolism, whose own "signature" includes such stars, together with a seven-branched candelabrum (the oldest of Jewish symbols, recalling the menorah of the Temple in Jerusalem) *as* Jewish symbols— and the words calligraphed in Hebrew: "I am a Levite [a member of the priestly tribe descendant from Levi, one of the sons of Jacob/Israel]." So, too, photographs of the Congregation of the Wilderness (*Kehilah ba'Midbar*) at prayer together. This is a mixed congregation—that includes a Polish Jew married to a Hispanic crypto-Jewish woman and one of whose leaders is a Sephardic Jew from Boston "who believes in the Messiah found discussed in the pages of the *Tanakh* [Hebrew Bible] . . . missed by normative Judaism, and distorted by Christianity and 'Messianic Judaism'"—that is its own ingathering of exiles in microcosm as so much of its ancestry was and is a diaspora in microcosm.

Raymond Salas, shown with prayer book opened, Shabbat candlesticks kindled, photographs of older family members in the background, asserts both a traceable ancestry to the sixteenth century, and "a strong oral tradition of our Jewish roots on my father's paternal side . . . and on my mother's maternal side of the family. . . . These relations are what ultimately convinced me, in 1991, to fully convert to Judaism and to be Bar Mitzvahed at B'nai Israel in 1992."* Conversely, Richard Romero, portrayed before one of his woodcarvings—an image of the Virgin Mary in prayer (Our Lady of Guadalupe), a double Star of David hovering above her—recalls his grandmother praying in the secret cellar room; his family memory is shorter than that of Salas, and his relationship to it more ambiguous. Reverend Father William E. Sanchez, shown blowing an elegant shofar (though it was only in 2001 that the devoutly Catholic priest was asked after he and his father were DNA-tested: "Did you know you were Jewish? Did you know you were a Cohen, descendant of Moses's brother Aaron [high priest of the Israelites]?"—to which he responded in the affirmative), is completely comfortable in his dual Sephardic Jewish and Catholic identities. Yet differently nuanced, the altar boy Joseph Garcia, his Jewish roots emerging to his awareness with some clarity by his mid-twenties, eventually became the Rabbi Yoseph Garcia, who as a crypto-Jewish rabbi "is helping others to discover their own identity. It is the moment of 'Ah ha!' that is truly thrilling to observe."

The trust in an inexplicable God, variously maintained in varied expressive forms through the centuries, offers its own echoes in the trust accorded to the camera eye

* All quotes from individuals come from the passages accompanying their images elsewhere in this book.

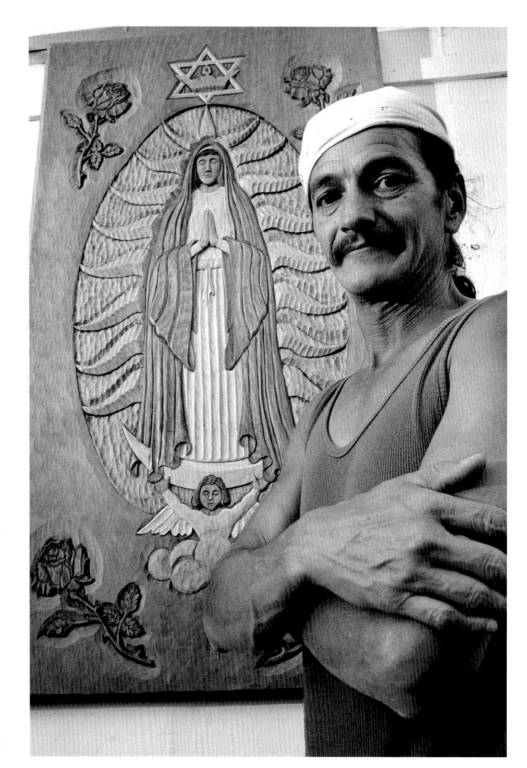

Santa Fe wood-carver
Richard Romero in
front of Our Lady of
Guadalupe with roses
and a Mogen David,
one of his carvings that
is in the permanent
collection of the
National Hispanic
Cultural Center in
Albuquerque,
July 21, 1994

through which Herz's eye sees the individuals re-viewing themselves as part of a large and complicated historical and spiritual whole. Cary Herz, then, is the border creature whose chosen instrument connects us to these individuals as they express their own bordered selves and their connectedness to interwoven pasts, and as they recollect and reassess the threads that define that weave. The truth she unravels balances on the boundary between unassailable fact and incontrovertible self-definition. It is shaped by fragments of memory, self, and the trust that permitted Herz to bring those fragments out of generations-long hiding places.

There is more, for as the camera eye records the weave of people, places, and objects into a new and still unfinished tapestry of identity, the photographer is not merely a passive observer of others' transformations. As a New Mexico photo correspondent for the *New York Times*, as a photojournalist whose clients have included *People*, the *Houston Chronicle*, *Hispanic Business*, *INC*, *Ms.*, and *Garden Design* magazines, *The Discovery Channel*, the *Los Angeles Times*, and a host of others, whose images have appeared in scores of books and magazines—she has typically been sent on assignment by others, the path to her involvement with her subjects paved before she got there. *This* body of work is different: it began with her own interest in this then largely hidden community—dating back to 1985. It grew out of her

own desire to come to understand the people she hoped to photograph, and by photographing them and their world, to visualize the invisible elements of their sense of self, their tie to their ancestry and the relationship of that tie to their present lives.

The journey through the labyrinth of memory and forgetting and of layered, interwoven identity led her to follow descendants of families once resident in Spain and Portugal back to those countries (in 1994 and again in 2000) as they sought the beginnings of themselves in visits to communities across the ocean whence their ancestors once fled. But more than that, "this photographic essay has redirected me back to my own spiritual center and my Judaism. It has connected me with my own past."

Reverend William E. Sanchez blowing the shofar inside his church in Albuquerque, November 2005

That past included the rarely discussed escape from Nazi Germany by both of her parents, rarely discussed simply because there was no reason to discuss it. Her mother would say that "many people had it worse, and we were young, nineteen and twenty-four, so bad things rolled off more easily"—or so lightly passed off to her young daughter in order to avoid discussing the escape and the powerful feelings discussing it would invoke. Herz's own past growing up in America included going to a high school (Bronx High School for Science) "with a 99 percent Jewish student body," where one might suppose that being Jewish was something taken for granted, and where the sense of the world and its relationship to Jews and Judaism might easily be obscured without parental conversations about their own recent refugee past.

Thus her own past included residence in that border territory of growing up among immigrants in a diverse New York City environment where becoming American meant both clinging (or not clinging, but if so, how *much* clinging?) to elements of one's European history from across the ocean (including elements of strong Jewish identity, accentuated by the keeping of Jewish holidays) and finding one's way through New York's own diverse labyrinth—and also looking beyond the city's western boundaries toward the vastness extending to another ocean. The edge on which she cut her photographic teeth was most specifically in photographing the birthing

Women's Movement in New York, watching the growth of the struggle to be heard in a world so long dominated by loud male voices.

And her career has carried her from the hidden, innermost recesses of the city, as a staff photographer for the *Star-Ledger* (Newark, New Jersey) to the wide-open spaces of the American Southwest for the *New York Times* and others—to a search for hidden memory and a will to reveal multiple senses of self that turned out to be even more personalized than she realized at the outset. In searching for a community repairing its sense of self (engaging in that obligation to help fix the world in whatever small ways possible, articulated in Judaism as *tikkun*) she was journeying back to herself (engaging in that act of reconnection to ourselves, others, and possibly even God, articulated in Judaism as *t'shuvah*).

"The Herz and Weinreb families were running away [from Nazi Europe and its contexts] just like the Sephardic Jews of Spain and Portugal during the Inquisition, for the same reasons. They all lost family but not their identity," Herz writes in her recent autobiographical reflections on this project. This sense of a common thread between her and them first led the photographer on a journey of discovery in the mid-1980s—she covered over ten thousand miles and stopped at more than 350 *camposantos* before ceasing to count—to find the gravestones with intertwined religious imagery upon them of which she had heard. That in turn led her,

finally, after a long struggle to gain their trust, to the people whose parents and grandparents and great-grandparents lay beneath the stones, which were emerging from carapaces of hidden identity as the 1990s blossomed—whom she had really been seeking all along.

Thus the interweave of memory and forgetting, of multiple religious identities that is the ostensive focus of her camera lens, also includes the interweave between the photographer and her subject. This is true with regard both to spiritual sensibility and to aesthetic sensibility. Is it accident or the artist's eye that places Isabelle Medina Sandoval like a tree standing among the trees, the angle of her upraised jaw echoing the angle of the scarf on which the light-colored flowers echo the snow florets to the right, and the dark background echoes the dark trunk and branches to the left? Can one's eye fail to feel a connection between the stitching of letters and images on Lorenzo Dominguez's tallit and the stitchery of the delicate branches that both frame him and repeat themselves in dappled shadows across him? The intense black lines against white on Jack Trujillo's tallit are reinforced by the dark lines of his own hair and those of the rocker in which he sits, dressed in white against the white of a spaceless background. Paul Salazar Carpenter is swallowed by the field flowers that push the eye back beyond competing fence posts and the sweeping dotted line of cattle toward the flowing hills.

The photographer's eye intertwines the threads of narrative, of "mere" photojournalism, with an exquisite artistry that is not imposing but enriching. As that interweave invites the viewer to reflect upon all the questions raised by Herz's images, it does what the Impressionists began to do in the era when photography was in its infancy: push the viewer to complete the picture. But her compositions do this by bringing to each image and taking from it not focal points or individualized engagements of pigment and horsehair, but lush visual statements that frame personalized questions of identity and memory forced to the surface by engaging each picture. Herz's work makes possible the efflorescence of a wide-reaching tree of beauteous thought and image from the seed that, she observes, "All of us have used in different ways to define ourselves in the twentieth and twenty-first centuries."

Ori Z. Soltes
Georgetown University

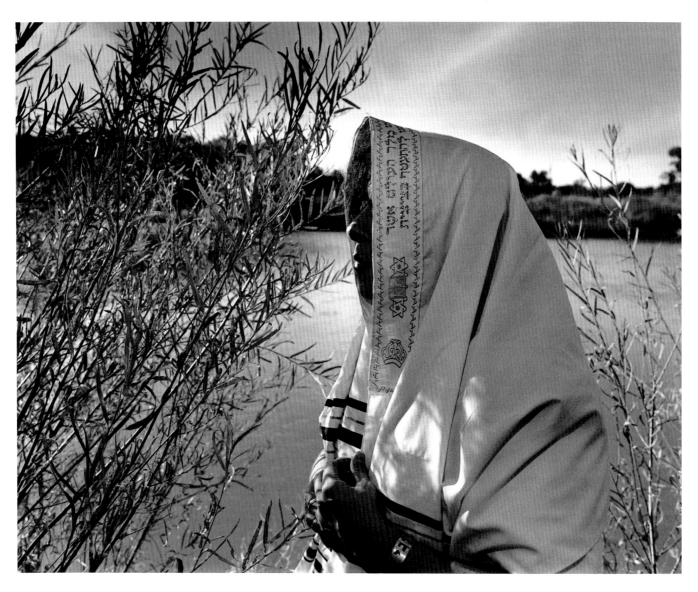

Lorenzo Dominguez, Levi ben Macario, by the Rio Grande, Albuquerque, New Mexico, 1999

Descendants

Lorenzo was a member of congregation Nahalat Shalom in Albuquerque, where he was the Sephardic cantorial soloist for Friday night Shabbat until his death in 2003.

Lorenzo's family on his mother's side dates back to ancestor Lucas Vixil (Vigil). A 1597 document found by his cousin absolved Vixil from all Jewish blood and baptized him as a Christian. This allowed him to travel to Mexico.

Lorenzo was a musician and a host and producer of a radio program called "Mi Seferino" (my little prayer book) for public radio station KUNM-FM broadcast around the United States. The title refers to the little prayer book that was hidden in the lining of the clothes of Spanish Jews during the Inquisition. The thirty-minute, bimonthly broadcast from the University of New Mexico covered histories, stories of culture, interviews, Sephardic folk tales, and Ladino music and was dedicated to raising awareness of the region's crypto-Jewish population.

Lorenzo told me, "The Ladino (Sephardic) music is something I've been listening to for a long time. Now with the High Holy Days music my spirituality has been enhanced and my circle is more complete." Lorenzo said he was not a crypto-Jew. "If I was, I would be practicing in secret."

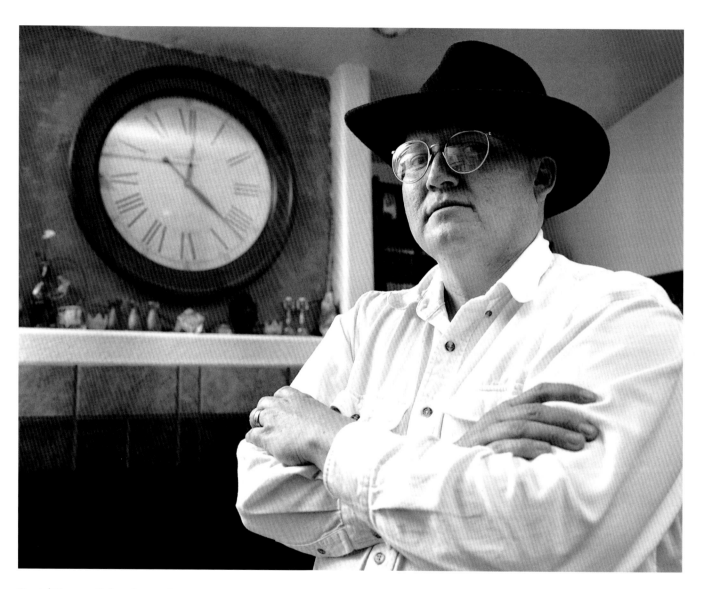

Daniel Yocum, Colorado, 2006

"My mother taught me about the Sabbath as a child. Many aunts and uncles (my grandmother's siblings) kept the Sabbath in my lifetime. The men went to pray with their tallits in a *morada* in the neighborhood on Friday nights. They covered the *santos* [saints] in the outer alcove with gunnysacks.

"We learned to slaughter animals in a peculiar way: saying a prayer; hanging the goat, sheep, or calf (never a pig) upside down; slicing the throat with a sharp knife in one stroke, allowing the blood to flow into the dirt. Some family members ate pork, but it was considered inferior. My grandfather Benigno Garcia called it a filthy animal.

"When someone died we did not watch TV, listen to music, laugh, or anything for seven days. The dead were buried quickly. Someone stayed with the corpse the night before burial. My mother, as a young girl, was often picked to perform this job. We also were taught to turn mirrors around for seven days [after someone died]. And when we visited cemeteries, we left stones at the graves.

"There was a man, a mohel, who died before my time, who circumcised all the male babies in the home where my mother and brothers and sisters were born. I was circumcised because my mom believes 'It is what, according to the Bible, makes a boy clean to God.'

"My grandfather had a handmade, carved, seven- or eight-candle holder in the garage (not used for cars but for storage—called a *cuartito*, little room). My grandmother did not want it displayed openly in the house. My grandfather

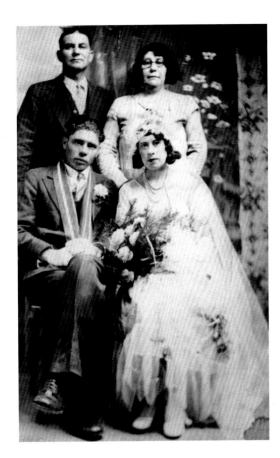

Daniel Yocum's grandparents' wedding

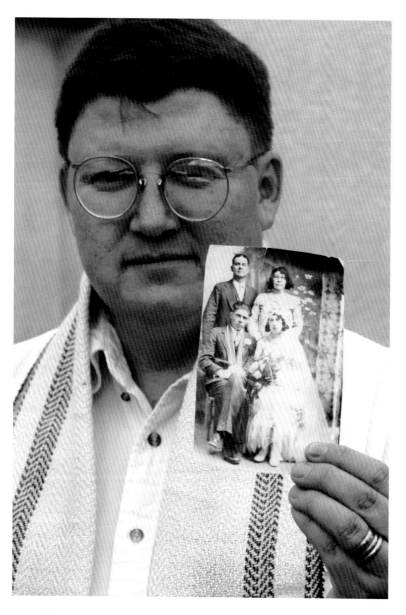

practiced these [Jewish] traditions with my grandmother's family. He was from Carñuel; she was from Atrisco, from land that the family has lived on since 1600s. In the photograph from their wedding he wore a 'scarf' that he always prayed in.

"My genealogy on my mother's side crosses Perry Peña's [see page 74] lineage in a few places. All documented ancestors descend from the Oñate and De Vargas colonizations. As far as I can tell, out of fourteen generations on my mom's side only one person was an Indian. My grandparents' marriage was obviously approved since who your family was more important than who you were. My uncles were hostile to my father marrying my mother until they learned that he could speak New Mexico–style Spanish [Ladino] and was familiar with many of their customs. Apparently, based on family legend and recent DNA testing, my grandparents' lines have Cohanim markers. Also the Jochems who became Yocums were from Holland and settled in New Amsterdam in the 1660s. They were referred to as 'Judis.'

"My brother Deward and I are putting together a trimmed down western Sephardic siddur. It will combine the modern Spanish and Portuguese siddur with Manasseh Ben Israel's Old Spanish seventeenth-century siddur."

Daniel Yocum with picture of grandparents' wedding

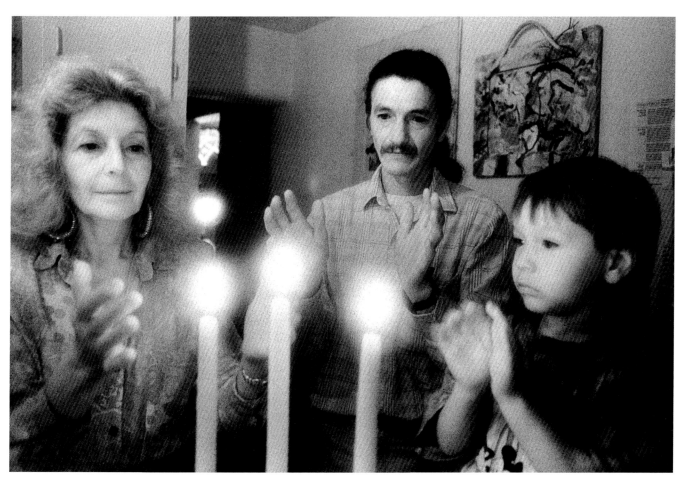

Richard Romero celebrates a Friday night Shabbat in Santa Fe with his son and friend, 1994

Richard remembers his grandmother's
secret room in the cellar of her home in
Truchas, New Mexico, where she went to pray.

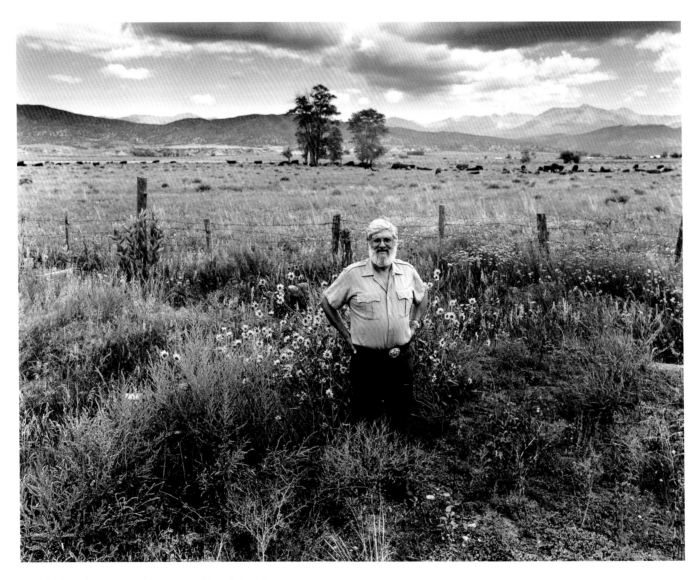

Paul (Salazar) Carpenter, San Luis valley, Colorado, 1999

Paul visited his grandfather's ranch in 1999 in the San Luis valley. His family moved from the Abiquiu area to the farthest reaches of the territories north [present-day Colorado] to be as far away as possible from the Mexican authorities. He said that when the Americans occupied New Mexico in 1846, they promised to protect the area from various Plains Indian tribes, including the Utes in the San Luis valley. The Utes were removed to western Colorado, and the valley was left open for settlement.

"My family took advantage of that opportunity and moved there. My great-grandmother took my grandfather Antonio Acario Salazar to San Luis in 1851, the year of its founding, and he later established the A. A. Salazar Mercantile Co.

"My mother never told me anything about there being a Jewish connection in our family. My cousin Leroy Maloney did most of the research about our family. It is only from gathering fragments of information that we have been able to conclude that we indeed have a Sephardic background."

Paul teaches classes for Elderhostel on the history of the Southwest and crypto-Jews.

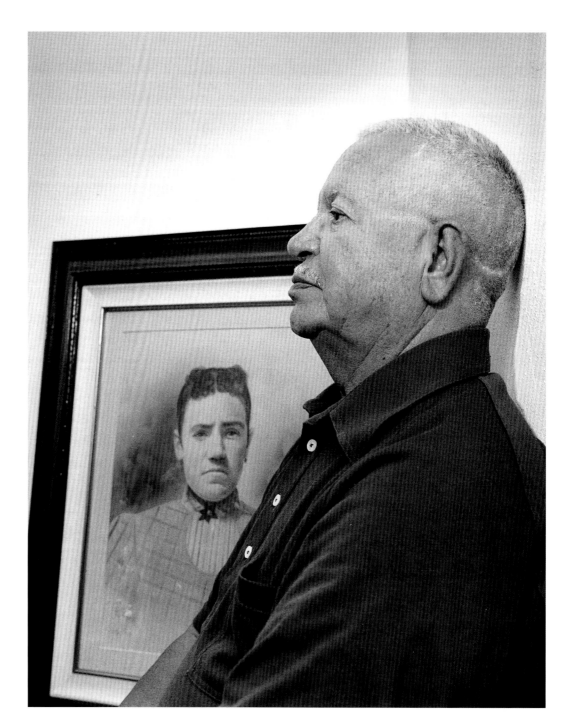

Emilio Coca with a portrait of his great-grandmother, Maria Emilia Casias de Coca, northern New Mexico, September 2005

Emilio described the portrait: "She is wearing a Sephardic *escudo*, a six-pointed shield, a Star of David."

Emilio told me Maria Emilia married his great-grandfather Lucas Coca in Ranchos de Taos. They had two sons. One was Emilio's grandfather, Abel Coca, who had a son, José Demetrió Coca, Emilio's father.

"My father said, 'We are people of Israel. *Sonomos gente de Israel*.' We are descended through eight lines to Juan Gonzáles Bernal.

"In our tradition, we did not go to the cemetery; we ate no pork; we slaughtered animals in the kosher fashion; we were circumcised; we lit Shabbat candles on Friday night. We went to the mountains for Jewish prayer."

Emilio has several *pon y sacas* (small, carved wooden tops—some call them *trompitos*) that his grandfather made to play with during the winter holidays. He has spoken out about his family's customs, and he and his wife Trudy have photographed many cemetery sites they believe are connected to the hidden Jews of the Southwest.

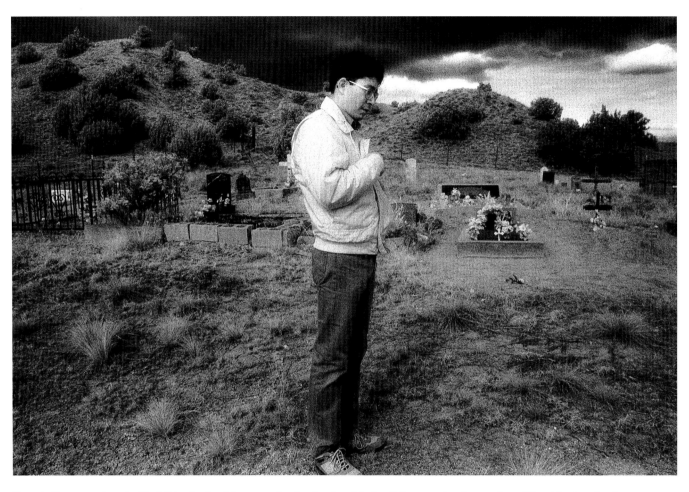

Dennis Duran recites the Kaddish, the Jewish prayer for the dead, at his family's gravesites in northern New Mexico, April 30, 1995

Dennis told me that both the maternal and paternal sides of his family originated in Portugal and came to New Mexico with Juan de Oñate in 1598. The maternal side of his family settled in Santa Fe County.

Dennis converted to Judaism in 1977, long before he traced his family's ancestry back to the Sephardic Jews of the sixteenth century. He said, "It just felt right." As others do, he associates certain customs from his upbringing with the Jewish faith. Dennis's paternal grandfather followed practices with kosher overtones, such as "slaughtering of animals, never allowing his children to eat at others' homes, and always eating lamb.

"My father and his older brother told me that they've always known and [it] was no big revelation to them that they were Jews. They were very aware of it growing up.

"There's only one Francisco Gómez Robledo of Portugal who was hauled down by the tyrannical Catholic Church to face charges for being a practicing Jew. He and his family pepper my family tree in quite a few places (and on both sides)."

I joined Dennis, Paul Marez, Gloria Trujillo, and Ramon Salas in 1994 in the mountain border town of Belmonte, Portugal, where we visited with people who had been practicing hidden Jewish customs their whole lives.

Dennis said about that visit, "I felt at home. Probably because I knew that my family was from there [Portugal], and that I had returned to one of my homelands. Once the people from Portugal understood that part of my family was from there, they seemed to let their guard down and accept me."

I was traveling with *New York Times* reporter Kathleen Teltsch. We worked together on many stories about New Mexico's culture for the *NYT*, including two on the crypto-Jewish community in the state, in 1990 and 1992. We had rented a very small car during the trip. When we left Belmonte, Dennis and Paul Marez accompanied us down the mountain to the seacoast and Lisbon.

One of our stops was in Coimbra, a city that dates back to the Roman era. Dennis and I went to visit the Old Cathedral in the plaza. When we approached the building, Dennis became very quiet and sad. He said, "Some of my family was murdered in the plaza in front of the cathedral by the Catholic Church for being Jewish."

In past years Dennis has been president of the Society for Crypto-Judaic Studies and the New Mexico Jewish Historical Society.

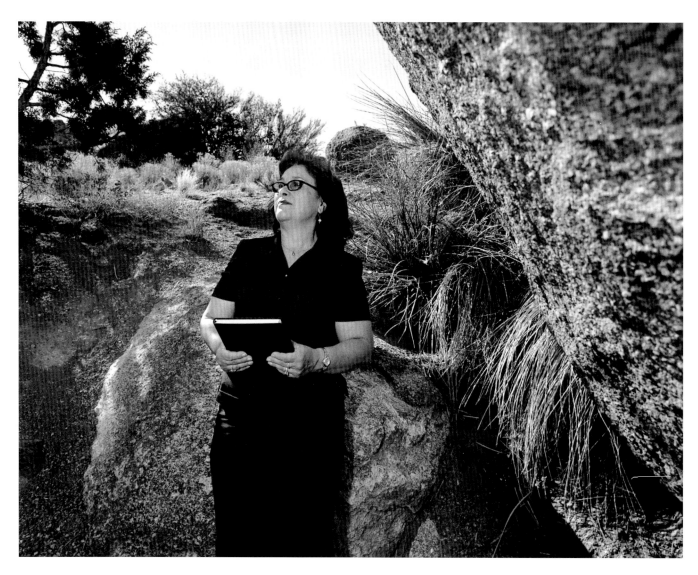

Maria Apodaca, Albuquerque, May 20, 2006

"My father was Solomon Luna Apodaca. The second wave of crypto-Jews from Mexico came in 1698 and the Lunas settled near Isleta Pueblo. The family then came up the Rio Grande valley. In the 1706 settlement of Albuquerque my ancestors were Lunas, Candelarias, and Durans.

"I knew nothing until I was fourteen years old. My father said, 'I pray to God at home with my Bible.' I observed my grandmother putting water on top of her head three times, 'so my soul won't escape,' she said. In her mind it represented a *mikvah* [a ritual bath]. My father put his hands up to his mouth to say softly, '*Somos los judíos.*'

"My dad's second cousin, Paul Luna, was in his eighties when he said that the midwives circumcised all the men. He told me he always was Jewish, but registered as a Catholic because it was safer.

"I go back eleven generations on the Luna side to Francisco Xavier Luna, [born in] 1629 in Seville, Spain. I just found out that the Luna name was changed twice. It was changed to Miguel De San Juan Luna ([born in] 1687) at Guadalupe del Paso Reyno de Nuevo Mexico, and again changed to Joaquin De Luna around 1720 near Isleta.

"My maternal grandmother's father's side was named De Iñigo and can be found on the J and J2 DNA project and can be traced to Semitic origins. I just found all this out [2006].

"I am no longer hidden. I did my Return* with Rabbi Lynn Gottlieb. The Hebrew hymns were so familiar. You can't be a Jew alone, because it is a community.

"Memory is my soul. *Night* by Eli Wiesel is the hardest book I ever read."

* Maria studied Hebrew prayers and Jewish laws and customs with the rabbi. Upon completion of her studies, there was a ceremony and a ritual bath (mikvah).

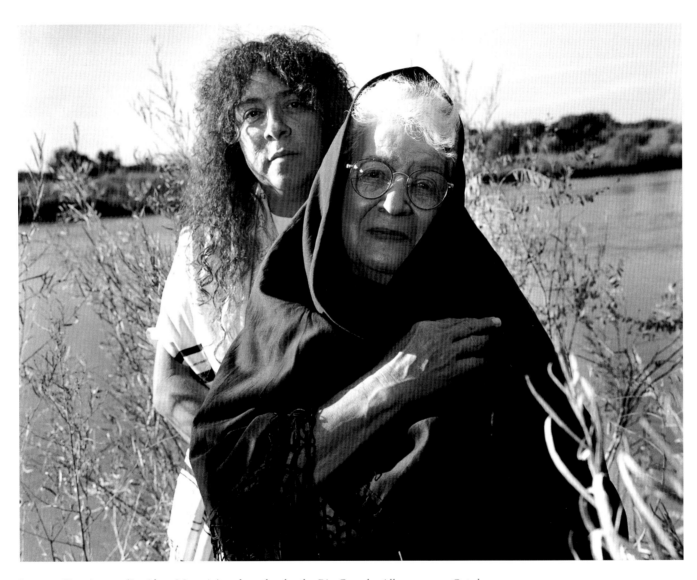

Lorenzo Dominguez (Levi ben Macario) and mother by the Rio Grande, Albuquerque, October 24, 1999

Lorenzo's mother Felima is still a practicing Catholic who acknowledges their family's Jewish ancestry. Lorenzo said that his mother's family dates back to ancestor Lucas Vixil (Vigil). A 1597 document found by Lorenzo's cousin shows that Vixil was absolved from all Jewish blood and baptized as a Christian.

In the photograph, Lorenzo is wearing his tallit and Felima is wearing her grandmother's black shawl. Felima said, "From the time he was young my son has always felt that he was Jewish. I have a daughter who feels the same way. For me, as long as they, my children, pray to God, as long as you live your life in a good way, that is all that matters."

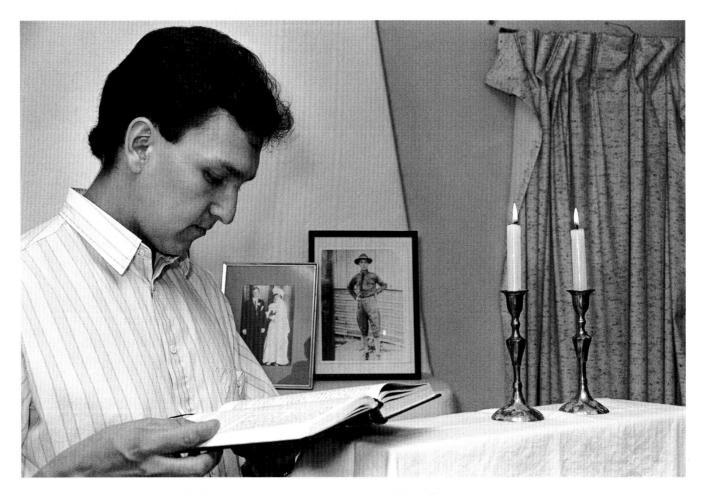

Ramon Salas reads Friday night Shabbat prayers at his home in the South Valley, Albuquerque, October 24, 1990

"My family can trace its origins back to the original colony settled by Oñate in 1598 and certain lines to later settlers, most notably my direct Salas ancestor, Sebastián de Salas, who arrived in Mexico City in the 1680s. He made it to New Mexico by 1692. There is a strong oral historical tradition of our Jewish roots on my father's paternal side of the family (where older folks would tell their grown children and grandchildren that we were originally "*israelitas*") and on my mother's maternal side of the family, where my great-grandfather Simón Tafoya often related to his children and grandchildren that we were of Jewish descent, pointing to specific ancestors in the process. These relations are what ultimately convinced me in 1991 to fully convert to Judaism and become Bar Mitzvah in 1992, coming up to the Torah at Congregation B'nai Israel in Albuquerque."

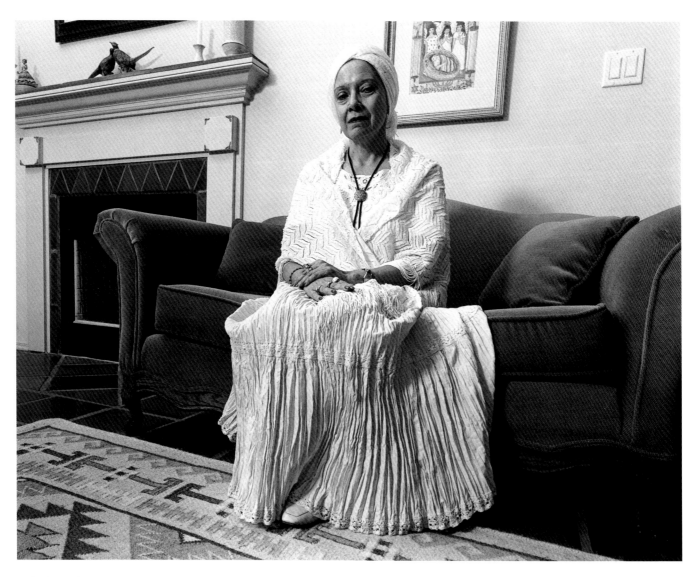

Isabelle Medina Sandoval, Santa Fe, 1999

Dr. Isabelle Medina Sandoval, an educator and poet, has traced her lineage back to crypto-Jews who fled the Inquisition.

"We always used kosher Mogen David wine for special occasions and Friday nights, even though we were part of a church that did not drink wine," Isabelle told me.

As a child in Wyoming, her mother gave her a memorial silver dollar to commemorate the Ten Commandments and told her not to believe in everything she was taught at their nondenominational church. Her grandfather in Mora County (New Mexico) always drained the blood to the ground from animals. In her poetry she has written about the identity issues intrinsic in being Hispanic and Jewish.

"As a small child I always felt I was different. Judaism puts into focus who I am and what we share [as Jews]."

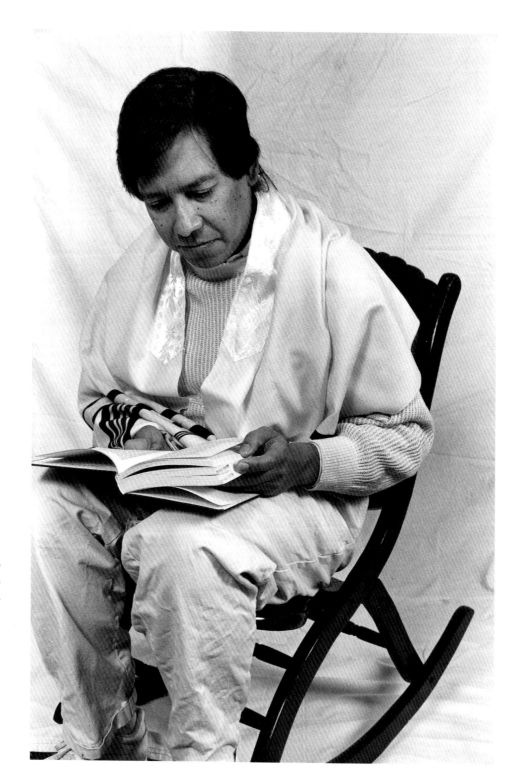

Jack Trujillo,
Albuquerque,
November 1992

"We trace our family to Mexico City in 1621, arriving in New Mexico in 1640. Family lore says we were from Extramadure, Spain. My father's father moved from Santa Fe around 1850 to Sierra County to get away from the Americans, though it may have been the forts along the Rio Grande that opened up territory to new settlements. Family legend says it took fifty years to build a church.

"My aunts talked about *los viejos*, 'the old ones,' and their odd habits. The habits I remember were all funeral customs like mirrors being covered, and a period of not shaving or bathing after a death. My mother lit candles on Friday nights, but says only because her mother did it.

"I do not have a conflict with a dual spiritual life. I've never understood Catholicism since elementary school. I started going to synagogue in San Francisco, where I put on a yarmulke [skull-cap] and heard the High Holy service at Shahar Zahav. I tried many churches, some of which I greatly enjoyed. But there [Shahar Zahav] I knew deep in my bones that this was where I had been and where I should be. Today I am a member of Nahalat Shalom in Albuquerque."

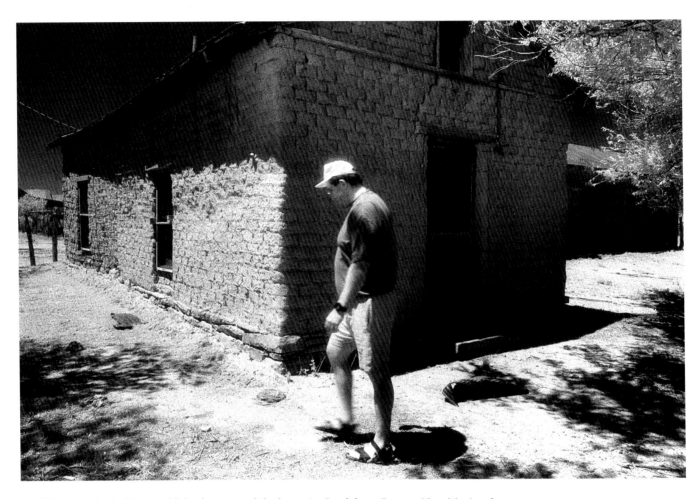

Paul Marez walks by his grandfather's empty adobe home in Guadalupe County, New Mexico, June 11, 1995

Paul remembers his grandfather, a rancher, slaughtering beef in the kosher fashion, letting the blood run down after cutting its jugular vein. "The family did not consume the blood. It just was drained into the earth," he said. "Also the men were circumcised; we did not eat pork; and the mirrors were covered after someone died."

In 1995 Paul took my parents and me to eastern New Mexico to show us a gravestone with two seven-pointed candelabras etched into the stone. His grandfather's home was nearby. He showed us where the meat was slaughtered in the kosher fashion. He said, "The family knew about their crypto-Jewish background."

Paul told us about his uncle, a Catholic priest, who said to him, "Did you know we're Jewish?" Paul was also told about his grandmother lighting candles on Friday nights, and said, "Around the winter holidays we played with a four-sided top, which we called a trompito. It was very similar to the Chanukah dreidel, though we did not celebrate that holiday. The trompito said 'put in,' 'take out,' 'all,' or 'nothing.' It had Spanish letters on it."

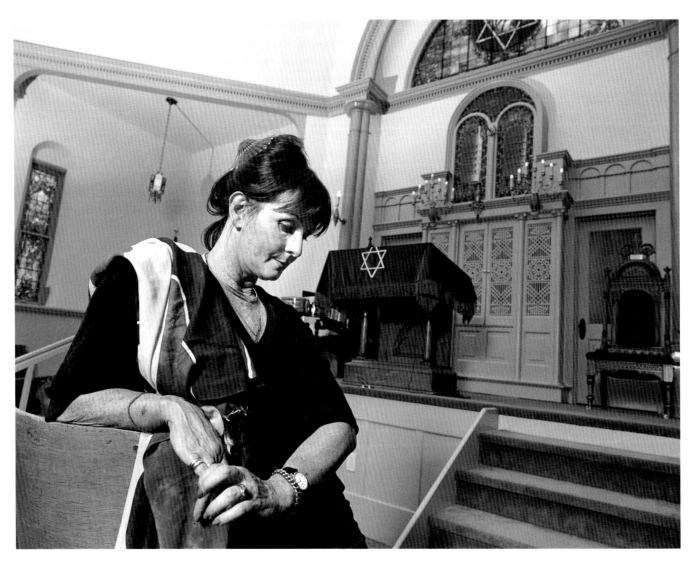

Rufina Bernardetti Silva Mausenbaum during her visit with New Mexico's
converso descendants, Temple Emanuel, Pueblo, Colorado, 2001

Rufina Bernardetti Silva Mausenbaum is from South Africa. Her family traveled through Majorca to reach the southern tip of Africa from Portugal. She came to Pueblo, Colorado, where I met her, to speak with other descendants of the Anusim.

She said, "Portugal is often described as having a rich and romantic past. For me, it is painful and tragic. My own origins, history, and culture have been effectively obliterated, and it is for me a continuing and haunting loss. My grandmother, whose name I bear, was thought to be 'odd' in the village where she found secrecy and anonymity. 'Odd,' because once a year (on the Day of Atonement) she used to disappear for a whole day and night. Her granddaughter, my cousin, died recently and was a devout Catholic, but had requested a plain, undecorated box and a 'simple' burial. There was to be no adornment, no jewelry or rosary.

"Although I was baptized in the Catholic Church, more than thirty years ago I converted to Orthodox Judaism, the religion of my forefathers, and often still experience some of the frustration, humiliation, and shame suffered by my family for centuries. Many families in Portugal maintained traditions and Jewish practices throughout the ages, some with no knowledge of where they originated as with most of my family who are Catholic but retain many Jewish traditions that have been passed down without explanation."

Referring to the Belmonte [Portugal] crypto-Jews, Rufina said, "A prayer said by crypto-Jews on entering a church featured the secret words, 'I come here to worship neither wood nor stone, I come only to worship you, Highest Lord, who it is that governs.'"

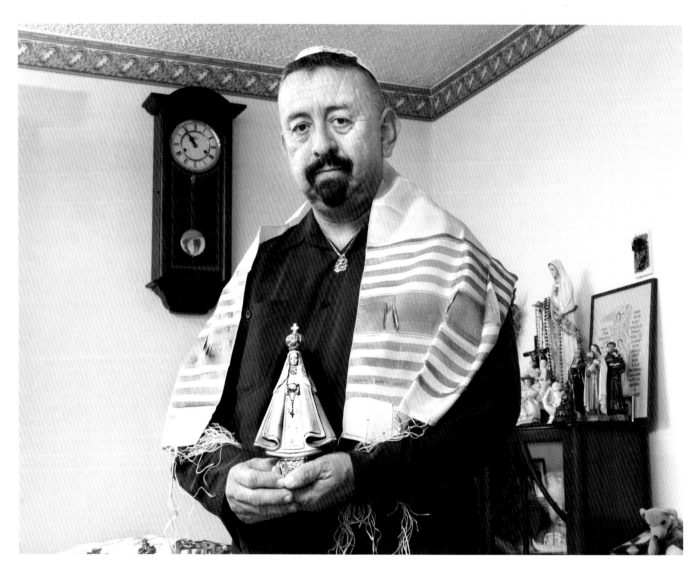

Richard Valdez wears a tallit he found after his grandmother's death
and holds a small statue of La Conquistadora, Albuquerque, May 12, 2006

"I am both Jewish and Catholic. My mother's side's ancestors are through the line of Diego de Vargas, who was the leader of the third group of colonists [to New Mexico] from Andalusia in Spain. We were an old Jewish family.

"My maternal grandmother is a Lujan. She lit candles on Friday night to the holy souls. She covered mirrors when someone died. She never swept until after the Saturday Shabbat. She kissed her hand and then touched the door. My cousin says it was the hidden *mezuzah*, an invisible remnant.

"We were from Ranchos de Taos and the Mora valley since the seventeenth century. The family were farmers and Penitentes. Grandmother was in the women's Penitente society called the Carmelitas. They prepared food and took care of the moradas.

"I have been going to Congregation Nahalat Shalom and a Catholic Church."

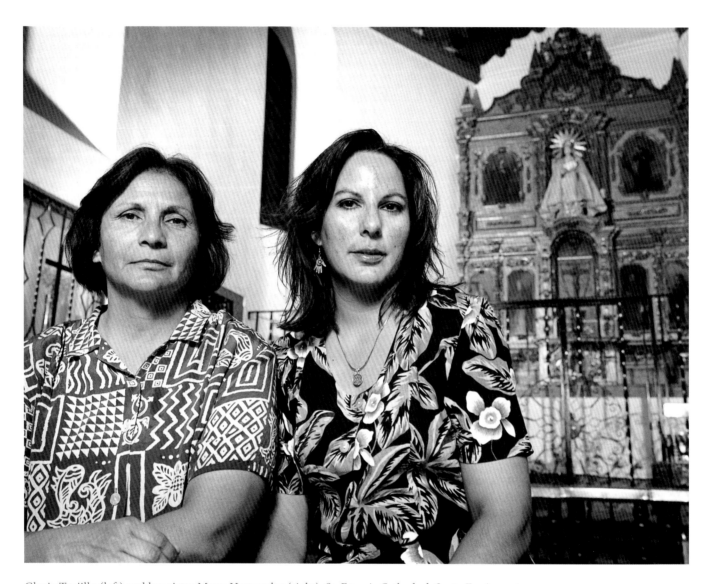

Gloria Trujillo (left) and her sister Mona Hernandez (right), St. Francis Cathedral, Santa Fe, August 9, 2000

Gloria and Mona spoke to me after visiting the St. Francis Cathedral, where the statue of La Conquistadora is displayed in its own chapel.

"My grandfather would go down into the basement to pray every morning and evening. He was baptized, married, and buried in the Church, but other than those times, he wouldn't go into a church. He always wore a hat in the house. When I was nine, we were leaving his house and he put his hands on my head and said a prayer," Gloria told me.

"I felt that the Mass had no spirituality for me," Mona added.

Gloria had a similar experience. "I felt I didn't belong there [in the church]."

Through diligent work the two sisters eventually traced their roots to the Gómez Robledo family, back to the Oñate and Vargas expeditions, and then directly back to Spain. Mona told me, "Francisco Gómez Robledo was arrested and tried by an Inquisition tribunal in Mexico City in the 1660s; he spent three years in an Inquisition prison. The men in the Gómez Robledo family were suspected of being hidden Jews. Gloria and I descend from this family."

"The thing was that all along I had the key," Gloria said. "I knew inside of me all of my life, but I hadn't put it all together. The more I learned about my Jewish heritage, the more it all fits into place."

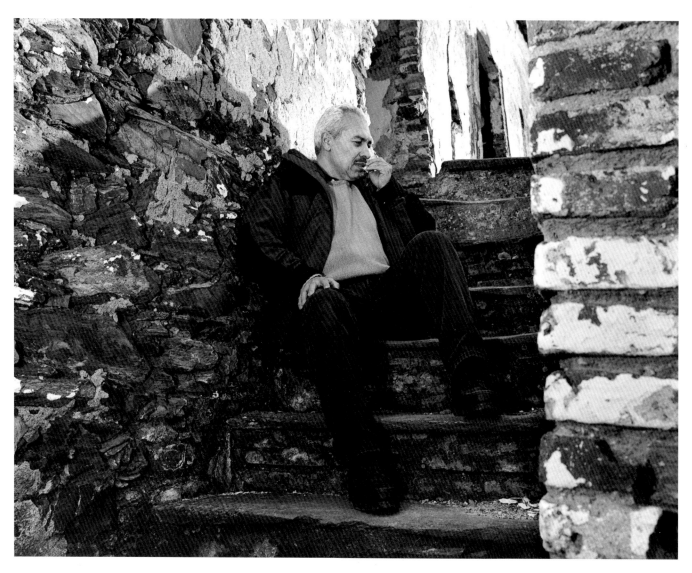

Gerald González sits on the steps of an Inquisition jail in Monsaraz, Portugal, a border town just west of Spain, 2000

"The paternal progenitor of my family, Sebastian González, arrived in New Mexico about 1600 to 1602 from Portugal. My mother's surname was Martinez but was originally Martin Serrano. They came from Zacatecas, New Spain (now Mexico), in 1598.

"In November 1995 an aunt told me that my paternal grandfather said we were of Jewish origin. This same aunt indicated that the Vaz/Vas/Bas/Baz side of the family was in 'deep trouble' with the Inquisition when Sebastian González and several brothers left for the New World.

"Delia González de Sanchez was my father's youngest sister and the aunt who first illuminated the González family's Jewish origins to me based on information passed on to her by my grandfather, Tomás González. My father's oldest sister, Estela González de Criswell, also confirmed this family history. A harbinger of this revelation was an odd statement my grandfather made to me in 1964, several years before he died. In Spanish he said, 'If I wasn't Catholic, I would be Jewish.'

"Sebastian González was married to Pascuala Bernal, the daughter of Juan Griego. He was a member of the original Oñate expedition of 1598.

Juan Griego was reputed to have died with his head turned toward the wall and the implication is that he did not die in a state of grace from a Catholic point of view. Indeed, some have identified this as a crypto-Jewish practice.

"Sitting on the steps of an Inquisition jail in Monsaraz, Portugal, led me to think of all the efforts required to conceal one's Jewish origins and cultural practices—and of the perils and journeys across the globe that my Jewish ancestors undertook to protect themselves and their faith. The risks were great—penalties for anyone outwardly professing to be a Catholic who was caught practicing Judaism in secret ranged from heavy fines and restrictions of personal freedoms to public penancing or even execution.

"In 2007 I identify myself as a Hispanic New Mexican who is culturally Catholic but who also has a deep awareness of and sensitivity to my Jewish roots—embracing them as part of who I am. Accepting the complexity of my family history (including the French and Italian branches along with my Jewish origins) has led me to seek a wider understanding of our relatedness as God's creations."

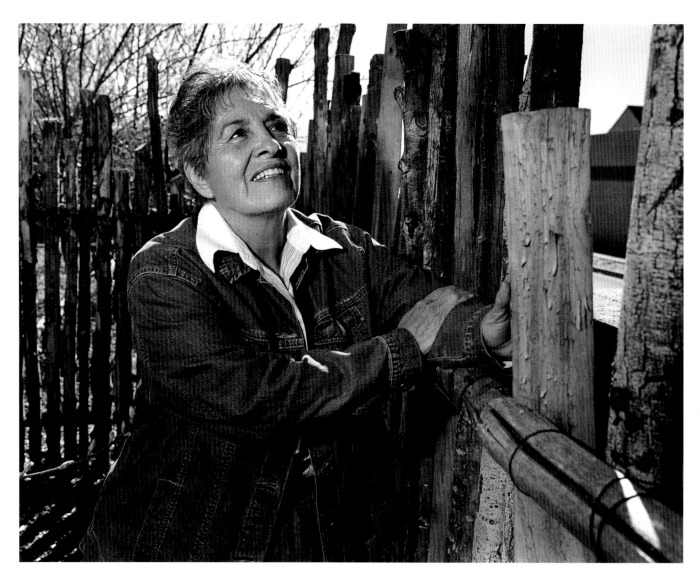

Jo Roybal Izay, Rio Rancho, New Mexico, 2006

"As a young girl living in Llano [Taos County], New Mexico, everybody spoke Ladino. Ladino is archaic Spanish and still spoken by Sephardic Jews in many countries, including Israel. The first time I ever heard the word 'judío' was when my grandfather Padrecito died. That was January 13, 1947. The evening before he died, my mother issued the Final Request as per Ladino tradition:

> I acknowledge to thee, O Lord my God, God of my fathers, Abraham, Isaac, and Jacob. The Lord reigneth; the Lord hath reigned; the Lord shall reign forever. Hear oh Israel, the Lord our God, the Lord is one.

"In prayer, minutes after his last breath, preparations to purify the body with hot water began immediately and all mirrors were turned to the wall. His daughters shaved and bathed him. They recited prayers as they proceeded to dress him in his best suit. They took the body to the room where traditionally the wakes were held. They placed him on an already prepared table, wrapped him in white linen, and lowered him onto the floor. The Kaddish (un sudario) was recited; everyone left the room.

"Early that evening the Penitentes, who led all Christian ceremonies, arrived and began praying and chanting. Sometime in the first hour, the white linen was removed and the body was lifted onto the table. El Hermano Mayor, the leader, placed a yellow collar around my Padrecito's shoulders. This item is called a sambenito [sanbenito].

"History tells us that in Sepharad (Spain) the heretics (Jews) had to wear a hooded yellow sambenito signifying they were heretics. This was the Badge of Shame! The Jews walked past the crowded streets where the pious Catholics cheered and jeered. Slowly, the Jews made their way to the stakes and into the burning fire."

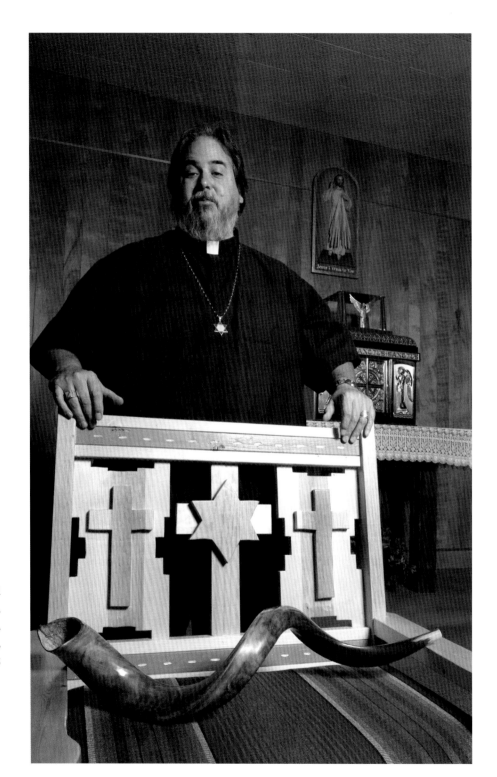

Reverend
William E. Sanchez,
St. Edwin Church,
Albuquerque,
November 2005

"My mother's maternal line is from the Carvajal family that came as colonists to New Mexico with Oñate in 1598, and that was the same family [Carvajal] burned at the stake in Mexico City by the Inquisition in December 1596. They intermarried with the Luceros. In 2001 my father and I were tested for our Y chromosome DNA and mitochondrial DNA by Family Tree DNA. The president of the company, Bennett Greenspan, called and asked if I was William Sanchez, kit number ___? Yes, I responded. 'Did you know you were Jewish?' Yes, I knew we were of Jewish descent. 'Did you know you are a Cohen, descendent of Moses's brother Aaron [high priest of the Israelites]?' Mr. Bennett then asked what I did for a living. 'I am a priest, a Catholic priest.'"

Reverend Sanchez told me that similar testing on other family lineages have also revealed Jewish ancestry.

"Several times a year, I will blow the shofar at my church, and I continue celebrating the Passover each year with those who wish to participate. Being Sephardic and Catholic began as a means of survival centuries ago; today they have both survived and coexist.

"I am back in the South Valley, the southernmost edge of Los Ranchos de Atrisco Land Grant, exactly where my Sanchez and Chavez ancestors lived in 1669. My journey to Israel [in 2005] was amazing."

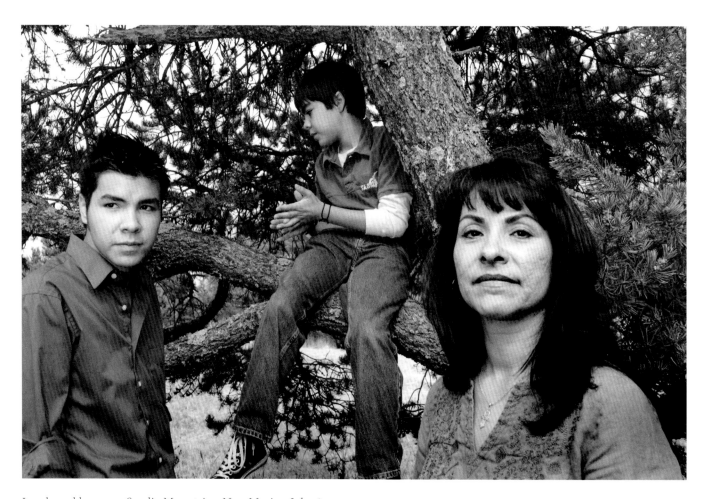

Israela and her sons, Sandia Mountains, New Mexico, July 18, 2007

"My family is from New Mexico; we have been here for many generations. We say that we've been here so long that we never crossed any borders, they crossed us, along with several governments. [In times past], on the ranch the children would take turns looking out for the priest. They would signal when he was arriving by shouting, '*Saguen, hay viene el cura*,' which means, 'Pull out the saints, the priest is coming.' They would use the word *cura* (healer, curandera/o) instead of *padre*, in order not to suggest a human was a 'deity.'

"Another great-grandmother would say toward harvest time, '*Hay vienen las cavanueles*' ('the time of the "huts" [sukkot] is approaching'). The family was fervently raised on the *antiguo testamento* (Old Testament).

"We had the common traditions of always sweeping to the middle of the room, never over the threshold; covering mirrors upon a death; cutting your hair only certain times of the month; and of course never ever eating blood, like the blood pudding some people ate. The meat was always salted.

"One of the grandfathers would tell the story that we were Jewish and had been expelled from our country; that's why we were here. The grandparents also spoke of the fact that we were of the Jewish tribes.

"On one grandfather's deathbed, he confessed that we were '*puros Judios*' ('all Jews') and spoke of the family lines.

"I did not want a crypto-family. My sons were raised with Chabad [the Orthodox congregation] and Temple Albert. . . . I did not feel I needed to convert since our ancestors had always known we were Judios. I did take a 'Right of Return' at Temple Albert. I struggled with this for a long time. The Right of Return was a private statement we made to ourselves, a point of reference for the future. Some family members don't like people knowing [about our background].

"My kids were raised knowing and studying with Loggie Carrasco. We joined her every week for music lessons and Sephardic Academia. We would also join her at Chabad for services.

"Reverend Bill Sanchez is my *primo* (cousin). He is related to me on my mom's side through two lines of the family."

Schulamith Halevy and Edie Lopez talk on a bench on the Santa Fe plaza, November 13, 1992

Schulamith and Edie said they felt like long lost Sephardic cousins after they met while attending a conference on the hidden Jews of the Southwest. Schulamith lives in Jerusalem, and Edie lives in California, though Edie's family is from New Mexico.

In the August 19, 1994, *Jerusalem Post*, Edie is quoted as saying, "I always knew there was something secretive about my family. When my mother was on her deathbed, she whispered to me, repeating the Hebrew name of God."

Helena and Michael Atlas-Acuña on the dais of Temple Emanuel, Pueblo, Colorado, 2001

Michael said, "The Mexican Inquisition tried several Acuñas who were Portuguese merchants. In 1990 my mother told me before she died that the family had Sephardic roots. She was studying to convert to Judaism before her illness took her. She said her grandmother lit candles on Friday nights and went to church on Saturdays. The family came from Mexico to Douglas, Arizona, in the 1900s, where I was born. During her illness she told me in Spanish that she wanted to die as a Jew. My brothers and I found a rabbi who performed her conversion while she was on her deathbed.

"I went through the proper conversion and consider myself a Jew of Spanish, Mexican, and Portuguese descent. My two brothers, David and Daniel, have done the same. I am very active in the Jewish community in Pueblo, Colorado."

Rabbi Yosef Garcia, Old Town, Albuquerque, April 28, 2006

"My maternal grandmother lit two candles every Friday night and moved her hands around in a circle saying words I could not understand. She swept the floors toward the center of the rooms, and she covered the mirrors with black cloth when someone died. When I asked her why she did these things, she said they were very old family traditions taught to her by her grandmother.

"In 1982 my elderly great uncle told me the reason I was uncomfortable in Christianity was because we were Jews. Suddenly it made sense to me, my mother shouting about the filth and toxicity of pork and the other family customs. My father cried when we celebrated Erev Shabbat in my home. It was the first time he had done so since his mother's death. I then realized that he had known all along.

"When I visited my mother's and her mother's town in Panama, La Tablas (Tablets of Stone), a resident asked me if I was wearing *tzitit*. I always do. He said everyone in the tiny town was Jewish.

"Eight years ago, I founded Congregation Avdey Torah Hayah (Living Torah) in Portland, Oregon, whose mission is to help crypto-Jews reclaim their heritage. Now the congregation is in Arizona."

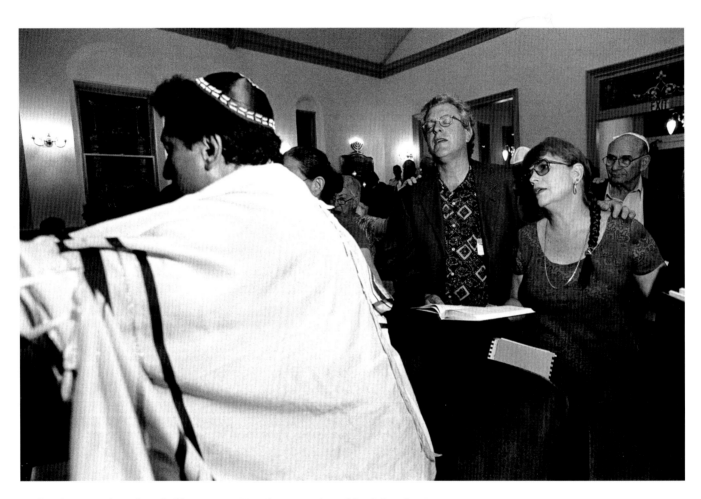

Paul and Tina Aviles-Silva, Shabbat service, Temple Emanuel, Pueblo, Colorado, August 20, 2001

Tina Aviles-Silva

"The Aviles family hailed from the Asturias area in northern Spain. Perhaps they actually came from Gijon or Oviedo, but they took the name of the town of Aviles as many Jews did from other towns.

"My father said that they left in 1532 and came to the Americas, and that an ancestor founded St. Augustine, Florida. His name is Don Pedro Menendez de Aviles. I was in that town and saw his name on the plaque on a wall of a building. My father was born in Guayaquil, Ecuador, in 1910. I found out about my father's family when I visited in 1975.

"On my mother's side my grandmother had all the children baptized, but my grandfather made sure all the boys were circumcised. According to my mother he would always say, 'Strange thing, all the Aviles boys are circumcised.'"

Paul Aviles-Silva

"I found out through my uncle Henry's widow that he had been circumcised in 1898, the year of his birth. At that time, I began to think that I might be Sephardic. My dad was circumcised in 1925, but would never discuss his heritage. He was very closed-mouthed and died about three years ago.

"I began attending services in 1997 at Temple Beth Shalom in Santa Fe. Tina and I were curious. My dad's grandfather, Antonio Gómez Da Silva, went to Hawaii from the Azores in 1887. He married Laura Vierra, and my paternal grandfather was born of this marriage. My father's parents both seemed very Sephardic. I never met my great-grandfather.

"I have discovered that having Jewish roots is very scary for most people. They know how dangerous it is to be a Jew. People grow up hating Jews, blaming them for the ills of world, and then find out that they are one of them! I am very comfortable in my life as a Jew. I converted four years ago."

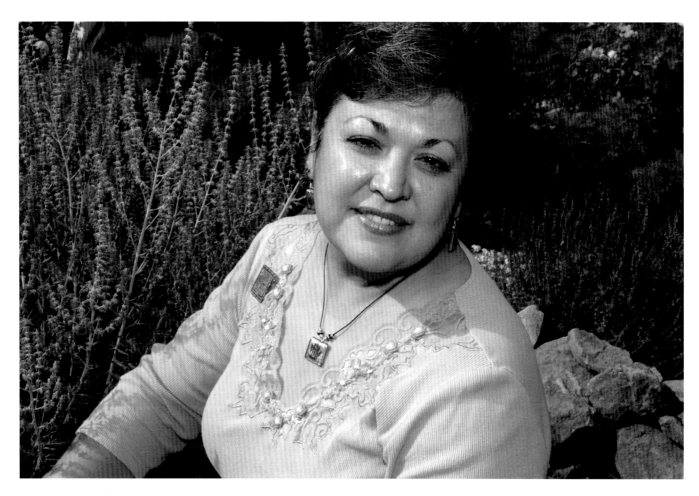

Sonya Loya, Ruidoso, New Mexico, August 1, 2006

Isaiah 58:6–14: Ancient ruins will be rebuilt through you and with you restore generations old foundations; and they will call you, "repairer of the breach" and "restorer of paths for habitation" . . . refrain from accomplishing your own needs on My holy day; if you proclaim the Sabbath "a delight," and the holy day of Ha Shem, "honored," and you honor it by not engaging in your own affairs, from seeking your own needs or discussing the forbidden—then you will delight in Ha Shem, and I will mount you astride the heights of the world; I will provide you the heritage of your forefather Jacob.

"Repairing the breach of five hundred years of forced conversion was my marching order thirteen years ago. I read this verse to my father for the first time in 2004. When I told him I felt it was time for me to repair the breach [by] restoring my ancestry back to Judaism, he said, 'I knew I was a Jew since I was six years old.'

"The repair is the *tikkun olam*, or 'repairing the world.' I started my Return and learning about Judaism in 1999. Loya, in the province of Navarra in medieval Spain, was populated with Jews. *Levi-ha* is the Hebrew for Loya and means 'the Levite.' My father's DNA test showed him to be related to the Levitical Jews.

"It does not make the journey any easier even when you know. My need for the truth surpassed my fear. The awakening in my soul is what keeps me going. I started working with Rabbi Leon in January 2005 and completed my Return in December 2005, on the first day of Chanukah, but had been practicing Judaism since 2000."

Sonya spoke to me when I visited her at her studio, Hosanna's Glass Works, in Ruidoso, New Mexico. She is also director of the Bat-Tzion Hebrew Learning Center, a source of education, outreach, and counsel to many crypto-Jews in New Mexico.

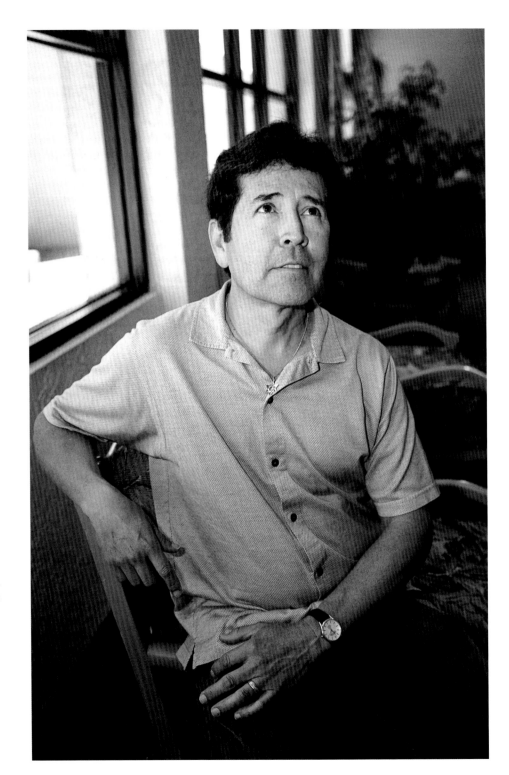

Richard Fernandez,
El Paso, August 2006

Richard saw his mother cover her bedroom mirror when his grandmother died and was told by his cousin that his uncle also covered the mirrors when their grandmother died. He said it is "both intriguing and scary for me to think that my ancestors were Jewish. There are many psychological and cultural obstacles to embracing this reality."

Richard remembers watching his mother and grandmother inspecting for blood spots in raw eggs and not using them for breakfast if they existed. His mother grew up on a farm in rural Arizona. She told him about how her father slaughtered animals. She said he would hoist them upside down and slit the throat with one quick motion, ensuring the blood drained into the ground. "My mother taught us that the blood would make you sick," he said.

"The last Judeo-Spanish connection was language, Ladino. They would say 'a dio ma,' meaning 'my God.' I understand it is an archaic form of Spanish and one that uses the Sephardic form of 'Dios' in a pious but misplaced grammatical attempt to emphasize the single nature of God through the removal of the 's.' It removes any hint of a Trinitarian plural [for God]. This discovery process has taken place over the last ten years."

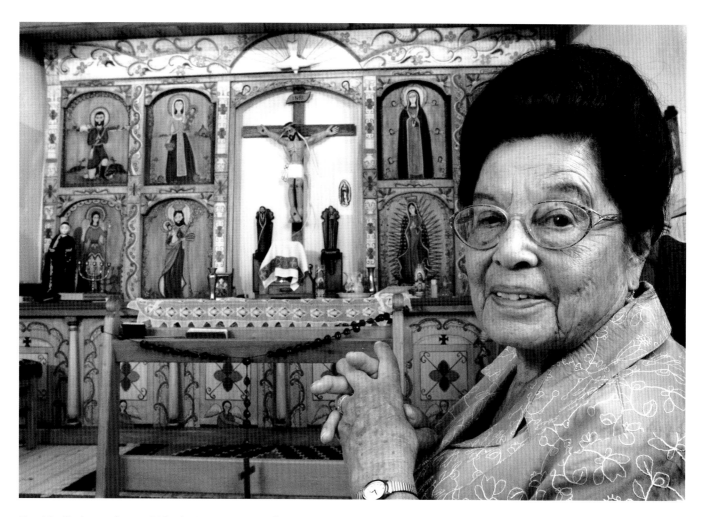

Zoraida Gutierrez Ortega, Velarde, New Mexico, July 2, 2007

"My father, Fidel Gutierrez, sent us to a Protestant high school in Santa Cruz. The priest told him to take us out of the McCurdy School. If not, he would not be allowed at Mass. My father stopped going to Mass. There were fourteen children in the family and four died from the epidemic [influenza] around World War I. I was born July 22, 1918.

"My paternal and maternal great-grandparents settled in Velarde around the 1700s. They were farmers. Antonio de Vargas, my maternal great-grandfather, was a lawyer. The people did not like him and he was murdered.

"My mother, Maria de Luz de Vargas, told us when we were small, 'Su papa hera Judio.' She was referring to her grandfather and father.

"We do not know very much more."

Zoraida was a schoolteacher and a weaver, and she helped her husband Eulogio with his carvings of saints. The carvings adorn their private chapel, Our Lady of Guadalupe.

Orlando Mondragon, San Luis, Colorado, August 31, 1999

I visited with Orlando several times at his gas station–laundromat in San Luis. He always welcomed me with a "*Shalom.*" He kept a tallit behind the counter, along with a Jewish Bible.

Rosario Chios Turja Delgado,
Ruidoso, New Mexico,
August 1, 2006

"I attend Sabbath services at B'nai Zion in El Paso when I can drive there with Sonya Loya. I have been attending Bat-Tzion in Ruidoso, New Mexico, for the past three years. My family came to Nuevo León in Mexico with the Sanchez, Perez, Bernal, and Blanco families in the early 1900s. I went to visit my aunt Rose Delgado, my father's sister, in Pueblo, Colorado, in 1985. Aunt Rosie said we are not Christians, that 'we believe in one God.'"

Alicia Campos outside
Temple B'nai Zion,
El Paso, August 6, 2006

Alicia is from Carlsbad, New Mexico. I met her at Temple B'nai Zion in El Paso while attending a conference on the Anusim. Her father's family is from Texas. She said, "About three years ago I started going to the synagogue in Carlsbad. My dad and I went to Texas to look for records about our family. My grandmother always covered her head and lit a candle. She did it in the Orthodox way."

Alicia and I talked about why she wanted to be Jewish. She said, "Because we were always Jews, but it was never talked about." She wants to know more about her past.

Flora and Isidro Chavez Jr., with their son Mark and his wife Imelda (Mondragon), Temple B'nai Zion, El Paso, 2006

Flora and Isidro Chavez, with their son Mark and his wife Imelda (Mondragon), attended a conference about the hidden Jews at B'nai Zion in El Paso, Texas. They went there to speak with and learn from other people discovering family histories.

Isidro said, "My father (Isidro Peña Chavez) butchered sheep according to the laws of the Torah. He was from Picacho, New Mexico. My mother, Martha Torrez Chavez, was born and raised in Tinnie. I was raised in Roswell. [For] festivals and sacrifices we also followed the Jewish law. The Spanish we spoke at home was quite different from the language spoken in Mexico. We have been pursuing this [family history] for eight years."

The Chavez family now observes the Shabbat and other Jewish sacred times in their home with their son and his family since there is no Orthodox Shul (Jewish synagogue) in their part of Texas.

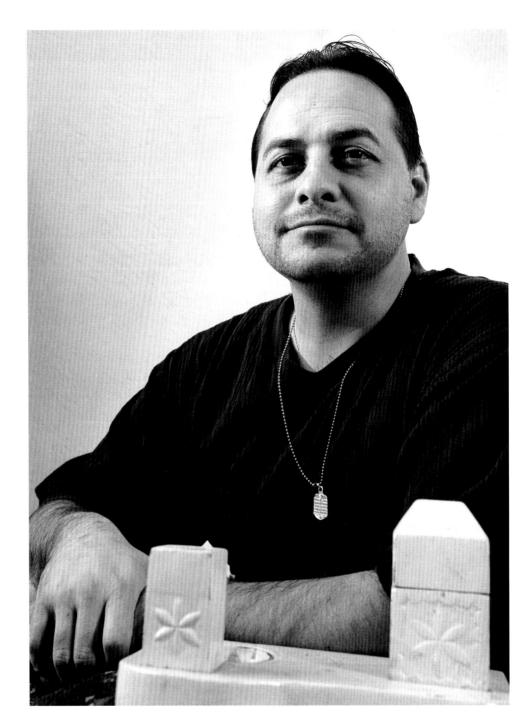

Perry Peña,
Albuquerque,
April 1, 2006

"The Mexican Inquisition murdered some Carvajals. The family was accused of Judaizing. The Carvajal family is connected to me several times through the governor's first cousin, Juan de Victoria de Carvajal, and his daughter who married into the Duran y Chavez line. My paternal grandparents, Juan and Elvira (Garcia) Peña, married in El Rito. They lived out their lives after the marriage in La Madera until they were very old, and then we moved them to Albuquerque in the 1980s. La Madera is a small mountain village in the northernmost part of New Mexico in Rio Arriba County."

In the photograph, Perry sits behind his grandfather Juan's wooden candleholder and incense burner, a havdalah set (used for the Jewish ceremony marking the end of the Shabbat or other holy days). His grandfather carved it with a six-pointed star, an icon that is found on churches and in flowers. Perry is a member of Congregation of the Wilderness, Kehilah Ba'Midbar. They meet every Saturday for Shabbat services.

Perry says in his book *Beyond Crypto-Judaism*, published in 2006, "I am a living descendant of the Anusim, or the crypto-Jews who survived the Inquisitions of Spain, Mexico City, and other locations."

Congregation of the Wilderness

ᴗ *Kehilah Ba'Midbar*

Perry Peña told me, "We would actually like you to take the pictures during the service as this is *tzedakah*, a mitzvah, a good thing, a service and encouragement to all the other fearful Anusim. When they see more than a havdalah (candle with more than one wick that is used at the completion of the Shabbat) and more than a scattered person wearing a tallit, this may bring them back around to who they are. Let them see there is more going on than just a fearful little whisper left in us. This is all, of course, if you can do the shots without stopping the service.

"Kehilah Ba'Midbar is a mixed group consisting primarily of several crypto-Jews; a Polish Jew married to an Anusim woman, whose family has certain crypto-customs and ancestry; a group leader [Joe] who is a Sephardic Jew from Boston, who believes in the Messiah found discussed in the pages of the Tanakh and is married to an Anusim woman of crypto-Jewish upbringing who is Hispanic. The service is Old Testament (Tanakh-centered), just like in a normative Jewish synagogue. We have a small Torah and read Hebrew from the Pentateuch. This past week it was Leviticus 9:13, along with a lively discussion on keeping kosher.

"Neither Joe nor myself believe in the Jesus put forth through Christianity. The Messiah we speak of is one that all Judaism claims to embrace on one level or another, the Messiah of the Tanakh. We do not embrace the New Testament . . . but accept these writings only as the Tanakh describes them, as testimony. We believe that the Messiah of the Tanakh coming twice is missed by normative Judaism, and distorted by Christianity and 'Messianic Judaism.' Our views may be seen as a product of the Inquisition, God only knows, but to the best of my

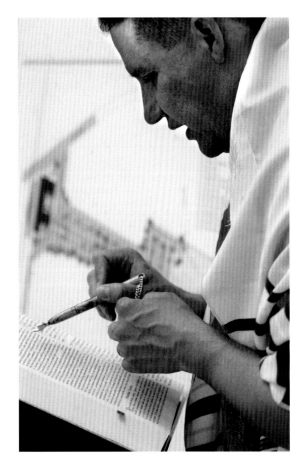

Deward Yocum, a member of Kehilah Ba'Midbar, Congregation of the Wilderness, reads from the Torah, Los Lunas, April 22, 2006

knowledge these views are not easily classified as 'Normative or Rabbinical,' nor can they fairly be called 'Christian' or associated with 'Messianic Judaism.' We do not want to be misunderstood, to be seen as a subbranch of any of the above institutions. We are uniquely Anusim."

Perry Peña, Roberto Gómez

Congregation of the Wilderness

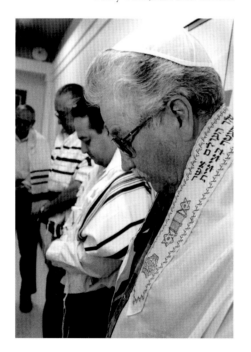

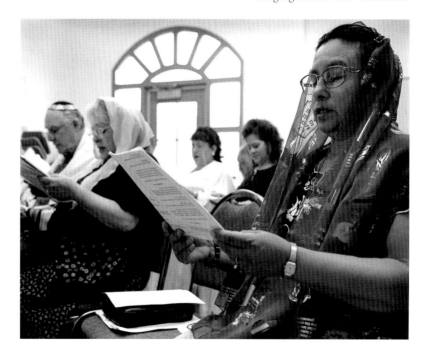

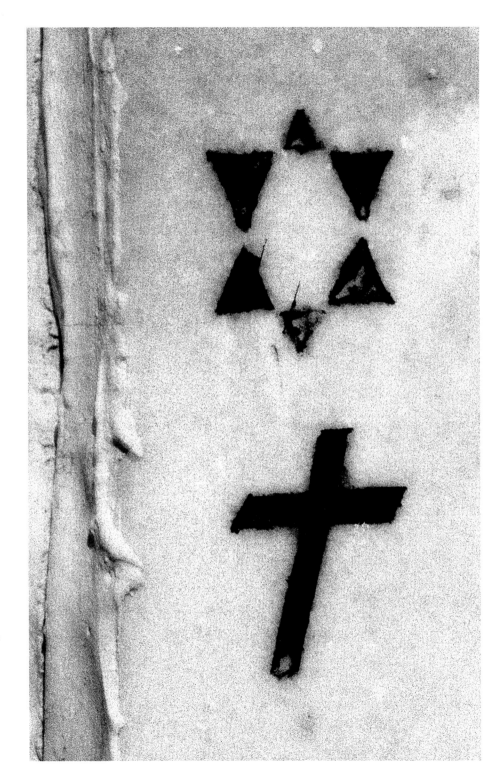

Cross and Star

Headstones

Persistence of Memory

In 1996 the *Chicago Tribune* ran an article about the descendants of Hispanic crypto-Jews in the Chicago area. One person interviewed said, "Don't even tell anyone I exist." The parents of a convert said, "There is nothing wrong with being Jewish, you just don't have to tell anyone about it."

Given such a strong tradition of secrecy, I am continually amazed that some Anusim still identify themselves with their ancestral faith. Some hidden Jews of this generation are less fearful and live more openly, acknowledging their beliefs more publicly. In 2006

someone I interviewed said, "We just are [Jewish], so we have to embrace our past."

My interest in the headstones began in 1986 when I saw a slide presentation presented by Emilio and Trudy Coca, who would not disclose the locations of the graves they exhibited. I asked them many times to tell me where to find them, but they refused. Intensely interested in the subject, I set off on my own. Driving the beautiful back roads of New Mexico, I wound my way through the mountains and valleys and along the rivers. I drove through the small villages along the Rio Grande valley north

to the Colorado border, along the spine of New Mexico and south into the Texas valley carved by the river that has done so much to determine settlement in three states.

Whenever I found a camposanto, I would walk along the rows so I could see two rows at a time. I traveled on foot, wearing my very old Frye leather boots because I was afraid of snakes. My only companion was Lincoln, my black standard poodle. He waited patiently in the driver's seat like a chauffeur while I worked.

Each burial site chosen for these photographs contains visual symbols of a hidden culture that survived underground for hundreds of years. Members of the crypto-Jewish community believe in and have interpreted these mysterious hidden codes. Because secrecy was and is at the heart of crypto-Judaic life, a serious tension exists between the solidity of the gravestones and the nearly invisible culture they depict.

The representations themselves raise questions: Why would a person, or the person's family, choose such a permanent identifying mark to indicate his or her connection with an unacknowledged ancestral past? Why choose symbols or names that could be identified by others of similar heritage? Given the dangers and the threats posed by the Catholic society in which they lived, why endanger the family by choosing such markers for the afterlife? Given their relative isolation, what motivated their descendants

to hold on to any Judaic beliefs, customs, or practices for five hundred years? And finally, why do some individuals continue to practice the customs of a Judeo-Christian faith?

All these images were taken between 1986 and 2006 in Catholic or Protestant camposantos in New Mexico, Colorado, Texas, and Arizona, where I saw hundreds of beautiful headstones with religious imagery, flowers, and candles. They were everywhere, and it was tempting to photograph every one of them, but I resisted. I only photographed those headstones that spoke to this mystery of the past. After visiting more than 350 camposantos and traveling more than ten thousand miles, I stopped counting how many sites I explored. Often I found only one stone that I felt was important, though when I returned to some locations I miraculously found another. In one instance the light had changed and an old stone lying flat on the earth showed two six-pointed stars on the sides of a cross.

Some of the people I photographed in the previous section are related to the deceased whose gravestones I show here. The stones offered clues to possible Jewish links between the present and the distant past. I found gravestones engraved with six-pointed stars, seven-branched candelabras, Hebrew letters, Stars of David, and a nine-branched candelabra (similar to the Hanukkah menorah). I also found small stones left atop the graves, possibly mimicking a contemporary Jewish custom. There are biblical names like Adonay,

Moises, Esther, Rebecca, Elijia (Elijah), and Yssac (Isaac). What do these stones prove? What mysteries do they hint at? I believe they show a connection to a lost faith for Hispanic descendants of crypto-Jews.

Dr. Rowena Rivera, professor emeritus of Spanish at the University of New Mexico, had been involved in the early research project, *The Sephardic Legacy in New Mexico*. As part of this 1987 project she spoke with northern New Mexican Hispanics about their oral history. She investigated their New Mexican Spanish language to see if it was similar to the Ladino spoken by Sephardic Jews in other countries of the world. She also researched the language in ancient documents in Santa Fe. When we spoke about this project in 2006, she said of these headstones, "You could tell some of the stones were not Catholic/Christian. It was so obvious the symbols were not Catholic."

I have undertaken this project with great respect for the privacy of the converso community, so I am not offering a road map to the stones. I have always been careful not to walk on the burial sites themselves, and I ask future visitors to do the same, to respect the cemeteries as special places where we honor and remember people who have lived in our communities and touched our lives.

I have been captivated by the stories of those emerging from the shadows. I hope that you will see these headstones as art as well as history and symbols, and bring your own insights, interpretations, and emotions to this remarkable historic record engraved in stone.

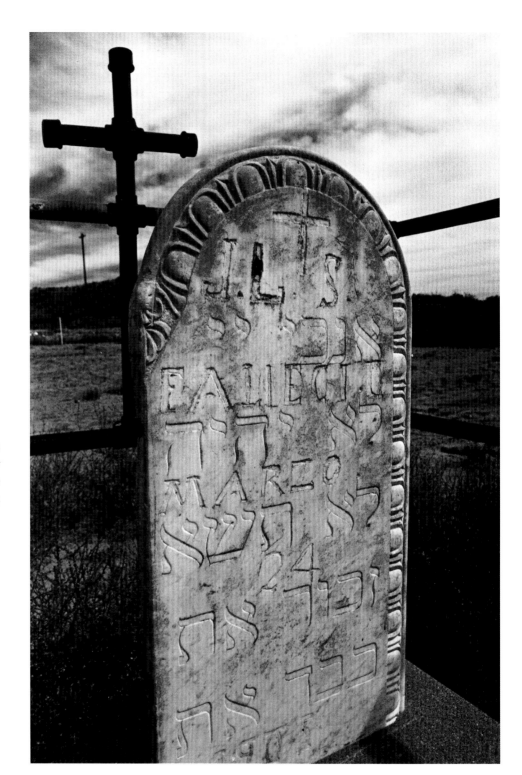

The Five Commandments
found in a Catholic cemetery
in the middle Rio Grande
valley, September 23, 1994

J. L. S. died Marco (March) 24, 1905. The Spanish initials and date are hand-etched into a tablet that contains the first five Commandments. It is enclosed by black metal with a cross above.

The Five Commandments

1. I am the Lord your God.
2. You shall not make for yourself an idol. You shall not bow down to them or worship idols. I, the Lord your God, am One.
3. You shall not misuse the name of the Lord your God in vain.
4. Remember the Sabbath and keep it holy.
5. Honor your father and mother.

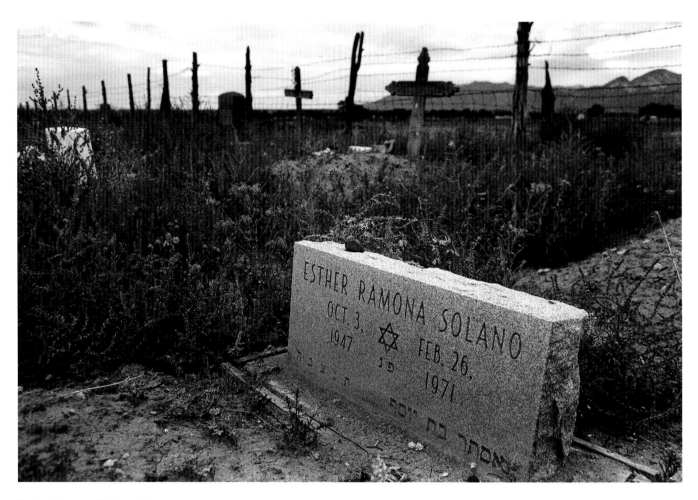

Esther Ramona Solano, May 15, 1990

Esther Ramona Solano died in 1971, when she was only twenty-four. The family's Jewish identity is marked with a Star of David, a six-pointed star, on the stone and the name of the deceased in English and Hebrew, "Esther bat Josef," Esther daughter of Joseph. She rests in a northern New Mexico camposanto. Solano is related to Emilio Coca and Gloria Trujillo.

Esther's brother has indicated to researchers that their mother knew they were Sephardic Jews and that she requested this headstone for that reason.

Like this one, most Jewish tombstones have the abbreviation, "*Pay Nun*" (the Hebrew letters), which stands for "*po nikbar*" or "*po nitman*," meaning, "Here lies."

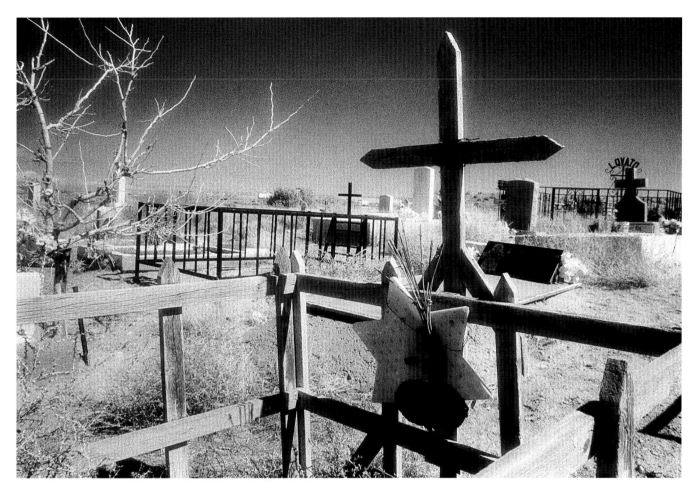

Star and Cross, March 1993

A six-pointed star, which is made out of yellow pegboard material, and a wooden cross are the icons used to mark this grave in Sandoval County.

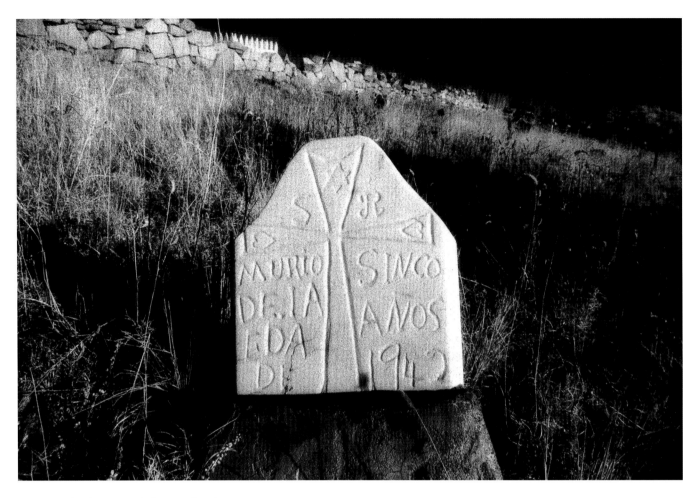

San Miguel 1, San Miguel County, October 20, 1993

This is the first stone I found, May 3, 1992, with a six-pointed star inside a cross. It is hand-carved and pearly white. S. R. died in 1942 and was five years old (*[c]inco años*). This stone sits in the old section of the camposanto among the tall grasses by a stone wall.

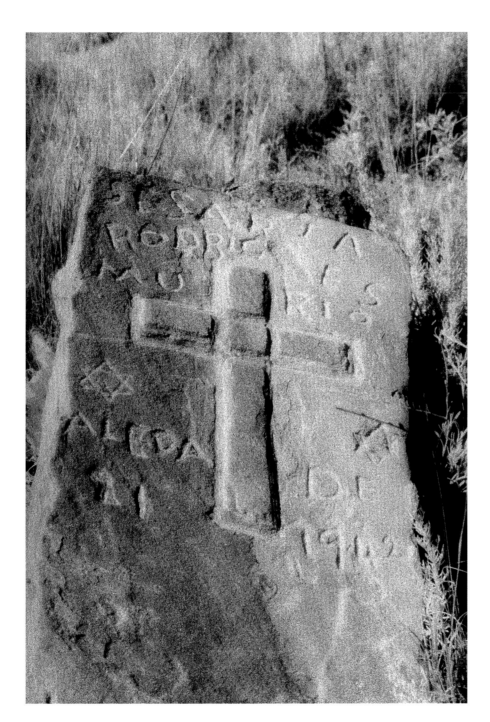

San Miguel 3, San Miguel County,
October 25, 1993

This grave lies flat in the ground,
surrounded by soft grasses. It is also
a hand-carved stone with a cross sur-
rounded by two six-pointed starts. I
did not see this stone until my third
visit here. The shadows had hidden it
from sight.

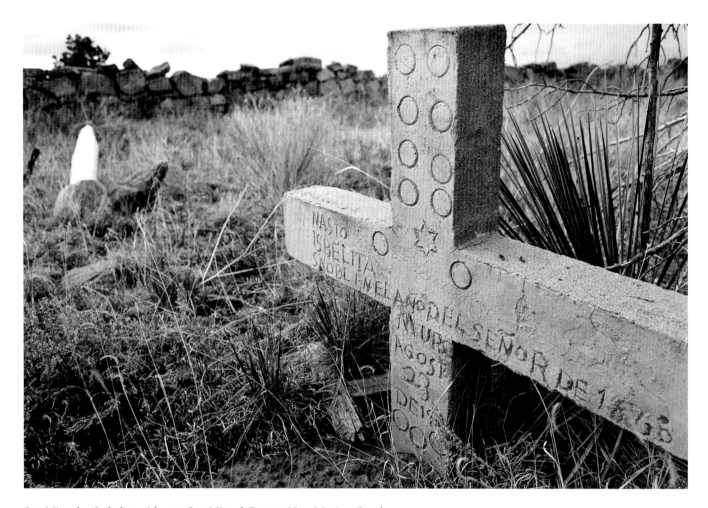

San Miguel 2, Isabelita with star, San Miguel County, New Mexico, October 25, 1993

⟪ This grave is handmade of ordinary concrete
with a six-pointed star and ten circles on it. What
does it mean? It is one of three in this cemetery.
You can see San Miguel 1 on the left. ⟫

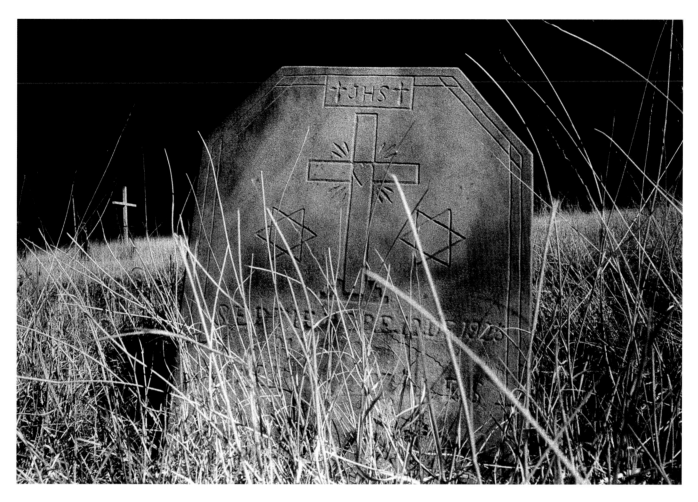

Dos Estrellas (Two Stars), October 24, 2000

This headstone has two prominent six-pointed stars on the sides of the cross. It hides among the grasses in a small cemetery near the New Mexico–Texas border. What does it mean? What do you see? What do descendants of the Anusim see?

Lone Star, October 25, 2000

 This lonely headstone is near an abandoned barn just inside the New Mexico border near Texas. Finally gaining trust among researchers and descendants, I was directed to this one's location.

Lone Star detail

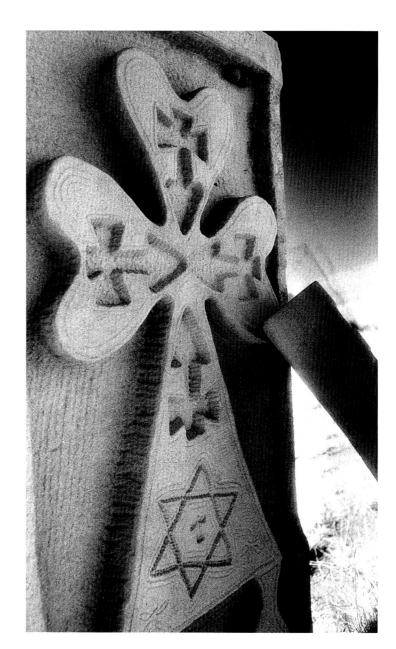

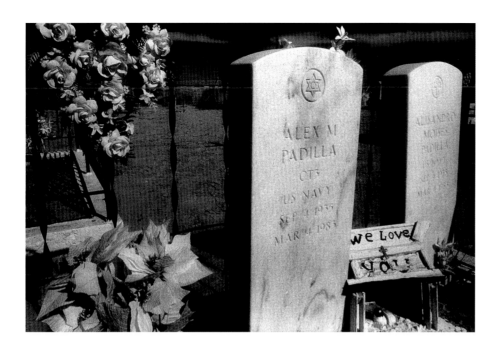

Alisandro Moises Padilla, middle
Rio Grande valley, April 17, 1994

Alex M. Padilla was born
September 4, 1935, and died
March 4, 1983. He has two mili-
tary headstones. One has a Mogen
David (Jewish Star of David) and the
second has a Catholic cross. One has
his Spanish name, Alisandro Moises,
and the other his Americanized
name, Alex M. According to the
Veterans' Administration (which
made these headstones), a sister and
brother simultaneously ordered the
different stones, so both were made
and sent to the family.

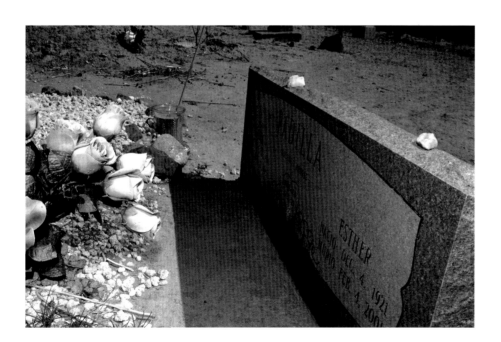

Isabel and Esther Padilla are
buried in the same cemetery as
their cousin Alisandro Moises
Padilla. There are small stones
atop their graves indicating some-
one has visited and acknowledged
the person's memory.

Padilla family members buried
near Alisandro Moises, middle
Rio Grande valley, May 5, 2004

Mary Alice Garcia,
northern New Mexico,
December 25, 1994

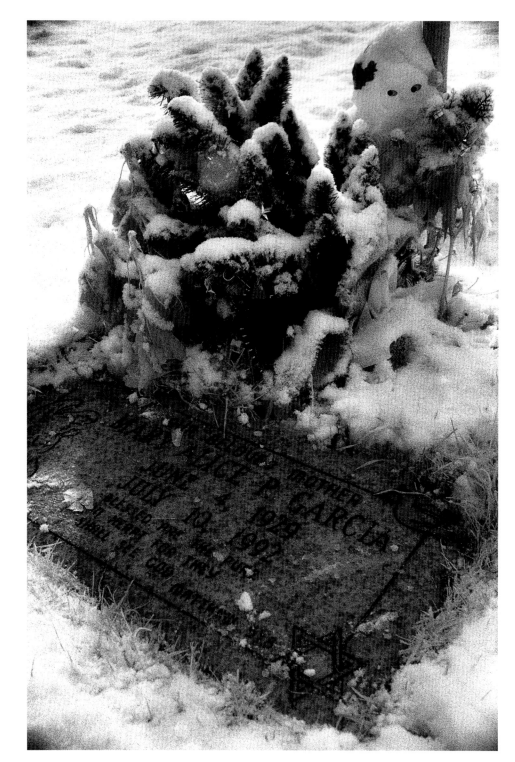

It is Christmas and a light
snow surrounds Mary Alice
Garcia's headstone. This was
my second visit. The stone is
adorned with an angel and
a six-pointed star, maybe a
Mogen David.

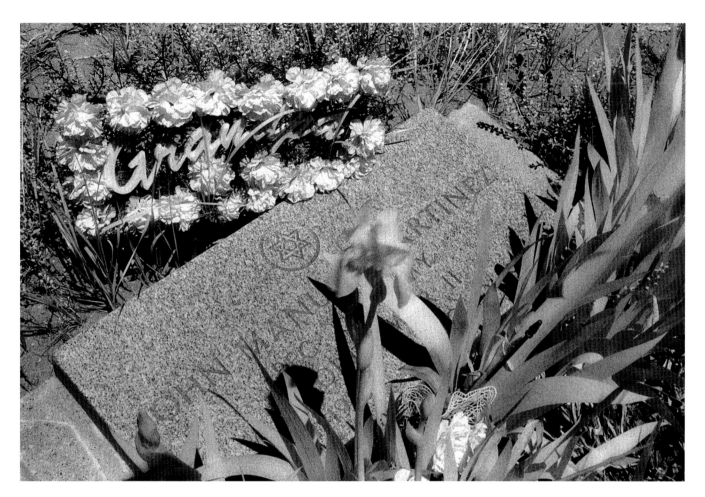

John Manuel Martinez, "Grandpa," May 21, 1994

In a tiny roadside cemetery in southern Colorado, I found John Manuel Martinez, "Grandpa." I was told how to find this camposanto, but it was still difficult to locate because it was hidden behind a hill alongside the road. Very far from home, I did not want to return without seeing it. I knocked on a farmhouse door. The people told me to look on the north side of the road, go another quarter mile west, and keep looking. I searched for a very long time until I found it. It was behind large boulders off the road. All the stones were flat to the ground and surrounded by irises and trees, which is why I couldn't see the cemetery from the road.

Two Menorahs, June 11, 1995

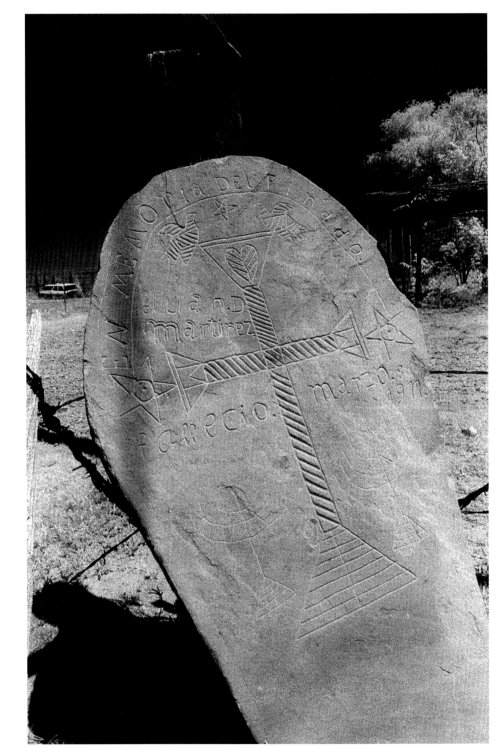

Two lightly etched seven-
branched candelabras (the oldest
of Jewish symbols, recalling
the menorah of the Temple in
Jerusalem) adorn Juan D. Martinez's
headstone, an ancestor of Paul
Marez. Martinez died in 1911. Paul
took me to this site, a small Catholic
burial site in Guadalupe County,
near the Pecos River, near his
grandfather's farm.

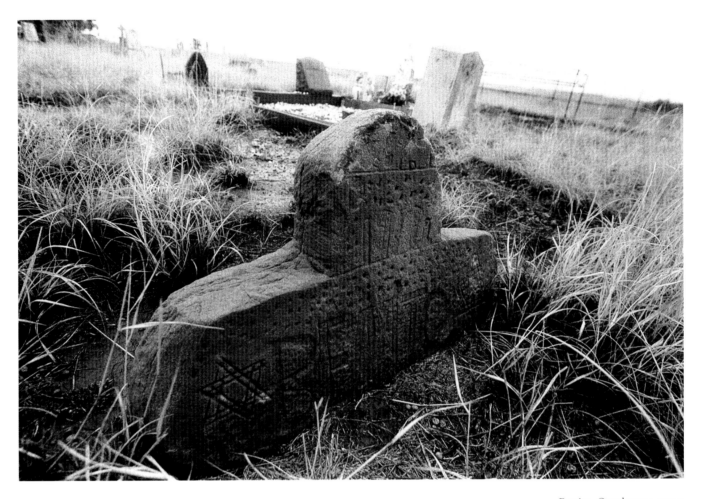

Benito, October 24, 2000

Benito rests among the grasses in a small cemetery in San Miguel County. His headstone has two six-pointed stars on a stone cross. This headstone is in the same cemetery as "Dos Estrellas."

Most camposantos where I found anything of significance had one stone and maybe some biblical names on the graves. Only in this camposanto and a few others did I discover several gravestones with interesting symbols.

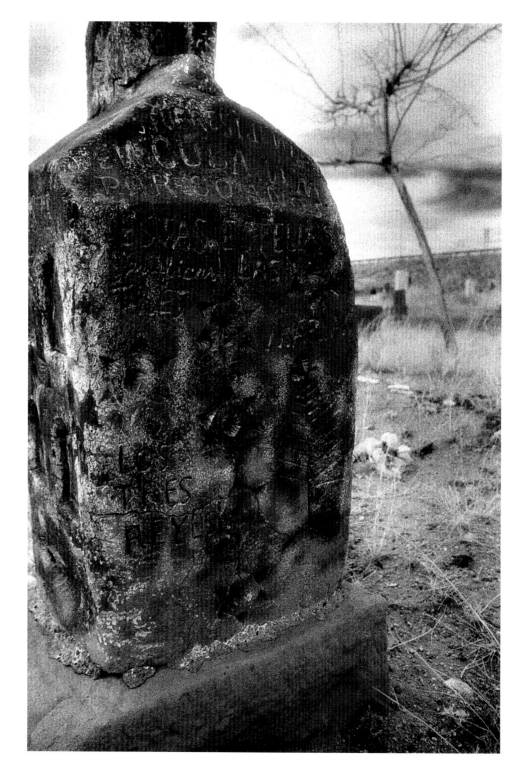

Rose, middle Rio Grande
valley, November 2, 1994

Her name was Rose,
and she was born in Cuba,
New Mexico. She has many
six-pointed stars on her
headstone. This was one
of the many stones that
Emilio and Trudy Coca
used in their slide presen-
tation in the late 1980s and
early 1990s to talk about
what they had found in
their travels.

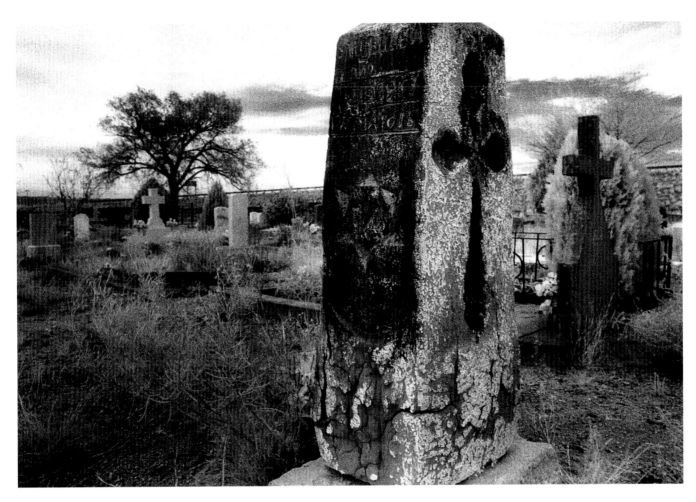

Rose's esposo, middle Rio Grande valley, November 2, 1994

Rose's husband was born in Cuba, New Mexico.
He is buried near her. His handmade headstone has
one six-pointed star and a cross on it.

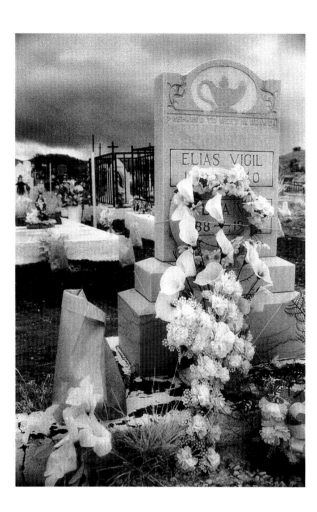

Oil lamp, Sandoval County,
New Mexico, December 30, 1994

Elias Vigil died in 1940. What
does this oil lamp mean to his
family? A member of the crypto-
Jewish community told me that it
is the sacred oil lamp to God.

Shin, northern
New Mexico, 1988

According to several Anusim,
the six-pointed lily holds a hidden
symbol for the Hebrew letter *shin*
inside the stamen. This letter
stands for *Shaddai*, meaning
"Almighty God."

Mother, August 31, 1988

⟨⟨ This grave has two hidden symbols: the six-pointed lily, and the small six-pointed star hand-etched inside the flower. This grave is located in a cemetery in northern New Mexico. One of the descendants I photographed has family buried here and showed me the two carved stars. ⟩⟩

Cleto Gomez, northern New Mexico, August 31, 1988

⟨⟨ Cleto Gomez's headstone has a small stone left on as a marker by a family member and also has Jesus on the cross embedded on it. ⟩⟩

Angel and Star,
Torrance County,
May 16, 1996

◖ Detail from a large
stone—a tiny six-pointed
star is etched over an
angel. ◗

Menorah/Candelabra,
Bernalillo County, April 13, 1994

Is a candelabrum that holds
nine candles a hidden symbol
for the Jewish holiday of
Hanukkah? Some descendants
of conversos think so.

Solomon Luna,
September 29, 1991

Solomon Luna's gravestone
stands tall in the Santa Barbara
Cemetery, Albuquerque. Luna was
from Los Lunas. Several scholars
and rabbis have looked at this
stone because of the shroud draped
on its top. Some descendants think
it represents a tallit, but they have
not found a definitive connection
between the crypto-Jewish com-
munity and the shroud.

Stanley Hordes and Tomás Atencio, Albuquerque, March 9, 1992

Stanley Hordes (left) and Tomás Atencio (right) stand in front of Solomon Luna's headstone, discussing the feasibility of New Mexico headstones having hidden symbols/icons that reveal Sephardic roots. The shroud is a common feature found in cemeteries all over the country. To make assumptions about these symbols, one must always be aware of the context of a family's history.

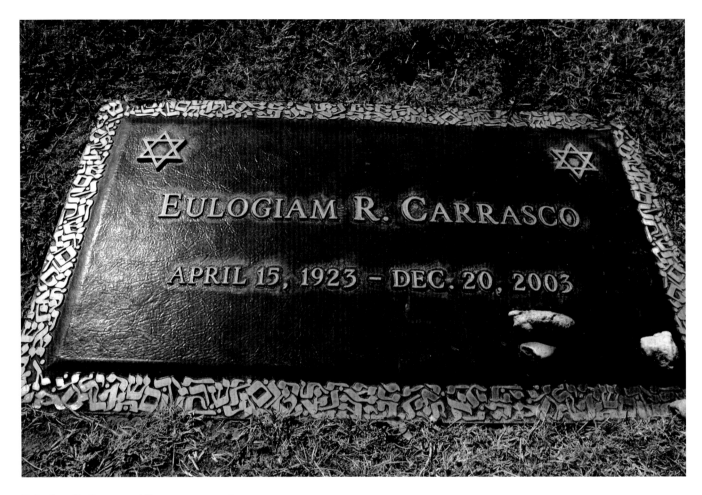

Eulogiam R. Carrasco, Albuquerque, 2006

 Loggie told me about some of her Sephardic ancestors in 1995.

 "Gonzalo Carrasco landed in Florida in the year 1528 [with Panfilo de Narváez, a Spanish explorer]. He was imprisoned in Mexico, but escaped to Cuba. Manual Carrasco was tried April 16, 1654. Rabbi Juan Carrasco left Spain for Holland during the Inquisition. Antonio Carrasco arrived in New Mexico in 1692 and was tried by the Inquisition in Mexico City. My name, Eulogiam, is Italian and Sephardic."

 Loggie lit candles in her grandmother's secret

room. She wanted to bring her people back to the Torah. She was a piano teacher and member of Congregation B'nai Israel (a conservative Jewish synagogue in Albuquerque) where she gave classes on the history of the crypto-Jews and worked in the gift shop.

She said, "We are *marranos* of the land grant, like *descarriada oveja*, wandering sheep. We have separated from Adonay. My maternal grandmother, Doña Eulogia, often talked about '*la corte celestial*,' the celestial court. The evening was spent in lighting candles in memory of our deceased relatives. Many Spanish families, descendants of the early colonists, still repeat such a service on 'El Día de Los Difuntor,' which is usually the last day in October.

"The Kol Nidre [High Holy Day of Atonement] service opens with this unusual sentence: 'By authority of the Court in Heaven and of the Court of men here on earth, with the permission of God and with the permission of this congregation, we declare it to be lawful to pray together with those who have transgressed.' During the Inquisition the Kol Nidre was often recited by the Spanish and Portuguese Jews [the conversos]."

I only have this one photograph of Loggie in which she is describing a menorah she made out of thread spools. She is speaking at B'nai Israel. Though she spoke with me often, she told me she was not looking for recognition and did not want a portrait taken. She died in November 2003 and was buried in the Jewish way. Many descendants of crypto-Jewish families knew her.

Eulogiam "Loggie" Carrasco

Biblical Names

The descendants who are speaking out believe that the biblical names from the Old Testament are another indication of the silent/secret past, including Moises, Rebecca, Daniel, Ysaac, Esther, Solomon, Elijah, and Adan (Adam), along with others. Also the surname Rael and the Hebrew name for God, Adonay, have possible connections to remnants of a Jewish past. People with these names do not necessarily have any knowledge about converso ancestors or practice the Jewish faith anymore. Nevertheless a name like this could be a vestige of those who were forced to convert during the Spanish Inquisition. During the days of the Inquisition, some crypto-Jews used Christian names in their everyday lives, but used Jewish biblical names within their secret religious community. After the Inquisition and the annexation of what is now New Mexico by the United States, these names were used more openly.

Adam (Adan) was created on the sixth day of creation by God.

Adonay is the name for God.

Daniel was a prophet who was faithful to God and able to interpret dreams and see into the future.

David was the second king of the Israelites.

Elijah was a prophet whose zeal brought about the abolishment of idolatry. At the Passover, the door is left open to allow Elijah to return.

Esther married a Persian king and concealed her Jewish birth. She was the quintessential hidden Jew. She saved her people from persecution when she revealed herself to her husband.

Isaac was the child of the elderly Abraham and Rebecca, and the second patriarch of the Jewish people.

Moises brought the Jewish people out of bondage from Egypt and received the Ten Commandments from God.

Rael is said to be a shortened version of Israel.

Rebecca was the wife of Abraham and the first matriarch.

Solomon was the son of David and a wise king of Israel.

Adonay, Sandoval County, December 15, 1994

Adonay Gutierrez died in 1980. Adonay (Adonai) means God in Hebrew. Was this name passed down through the centuries for a particular reason?

Elijia Rael, Bernalillo County, 1994

Here the name Elijia is used along with Rael, which some people think is short for Israel. Other symbols of crypto-Judaism could be the "Open Book" representing the Old Testament and the Hebrew letter *shin* inside the stamen of the flowers. The emerging crypto-Jewish community has been developing these interpretations. It is important to note these symbols have not been studied by material culture academics.

Ysaac, Rio Arriba County,
April 30, 1994

Here a woman bears this
name from Genesis. Some people
within the crypto-Jewish com-
munity see the two candles on
the stone as representing the
Friday night Shabbat candles.

Daniel Trujillo

Salomon Montaño

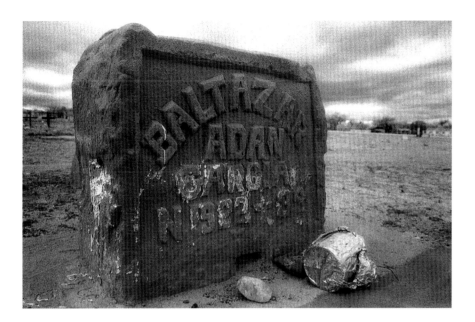

Adan

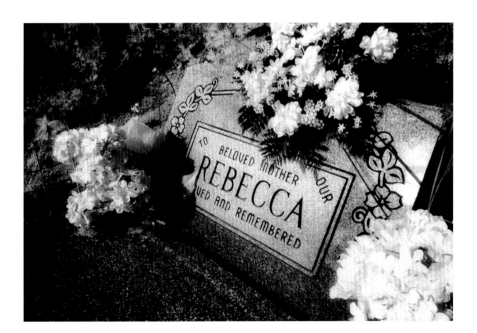

Rebecca

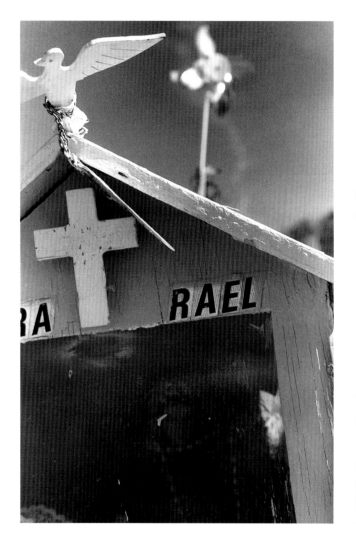

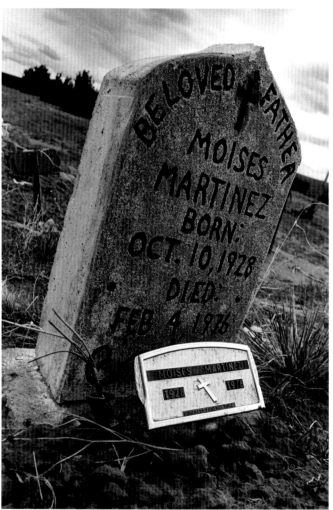

Rael Moises Martinez

Solomon

Moises Padilla

Esther

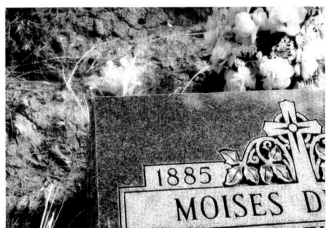

Moises, 1885

Church,
Elvas, Portugal,
2000

Portugal and Spain, 1994 and 2000

In 2000 I traveled with Gerald González and Stanley Hordes to border towns in Spain and Portugal. They were investigating family birth, baptismal, marriage, death, and census records in municipal and church archives and town libraries.

We met in Seville, Spain, and drove in the direction that the Jews from Seville and Cordova originally went when they left for the hills of Portugal during the fifteenth and sixteenth centuries. We went to many small border towns in the provinces of Extremadura (Spain) and Alentejo (Portugal). The town libraries of Elvas, Monsaraz, Villanueva del Fresno, Mourão, and Jeréz de los Caballeros had all the old documents bound in books that were meticulously preserved, catalogued, and viewable. In Monsaraz a man named

Josefe Gonçalves took us around the town and showed us the archives, the Inquisition jail, and an indentation on a house that he said was a spot where a mezuzah had been located.

Gerald González said, "Looking through the old records in Portugal, Spain, and the Canary Islands, as well as everywhere else I have done this, led me to 'feeling into' what the lives of those people may have been like. As you scan the names, look at the entries, think about the buildings and communities where [the Inquisition] occurred, you begin to get a sense of connecting to a feeling of the place. It's hard to explain because this is a nonlinear process. What it does is leave me recognizing how different our society is today from those [old] social networks and communities."

Gerald González and Stanley Hordes, Elvas, Portugal, 2000

Here González and Hordes are reading the old Portuguese records in the Elvas municipal library. Hordes is an adjunct research professor, Latin American and Iberian Institute, University of New Mexico, and has written extensively on the subject of crypto-Jews. González is retired as the Santa Fe County Manager and is currently researching and writing about his great-great-grandfather, José Tomás de Aquino Gonzáles.

Old obituary records are ready for viewing in the Elvas municipal library. González and Hordes examined these records along with marriage, birth, baptismal, and census records from towns along the border of Spain and Portugal during their research trip in 2000.

Elvas, Portugal

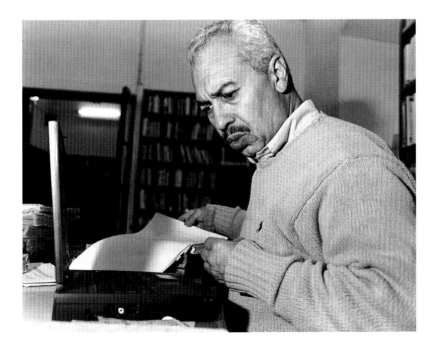

Gerald González in
Elvas Library, 2000

Dennis Duran looked for people with his surname in telephone listings. Here in Coimbra, an ancestor had been arrested and tried by the Inquisition and killed in the plaza of the cathedral. "Some of my family was murdered in the plaza in front of the cathedral by the Catholic Church for being Jewish," he said.

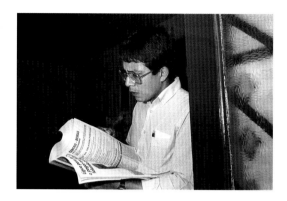

Dennis Duran,
Coimbra, Portugal, 1994

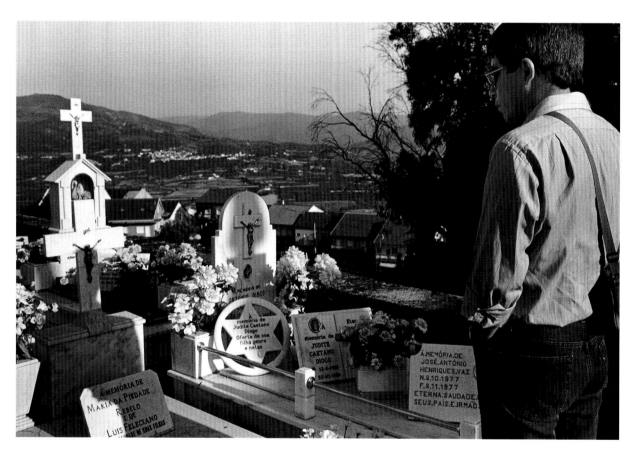

Dennis Duran visited the old Catholic cemetery in Belmonte. He and other New Mexican Hispanics went to meet with other descendants of crypto-Jews. Duran found several headstones on which a large Star of David had been added.

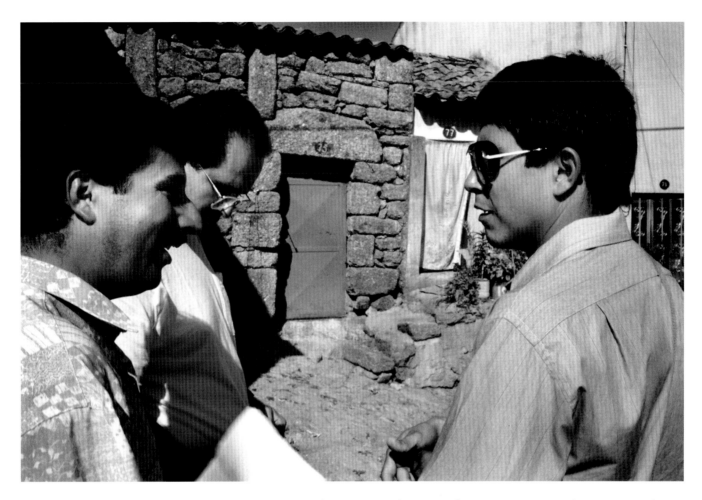

Elias Nuñez, Paul Marez, and Dennis Duran visit Belmonte, Portugal, 1994

(left to right) Elias Antonio de Sousa Nuñez, a local businessman, welcomes Paul Marez and Dennis Duran to Belmonte, located in the hills along the border of Portugal and Spain. In 1994 some cemetery headstones in Belmonte were being marked with Stars of David and Hebrew. Even though they were in Catholic cemeteries, the historically hidden Jewish community felt comfortable enough to start adding Jewish symbols to their ancestors' graves.

In Portugal, the New Mexican pilgrims traveled through the green mountains and valleys spotted with goats, sheep, and olive trees, very reminiscent of their home. They felt the people were like their *primos*, or cousins.

(left to right) Mr. Henriques, a member of the Sephardic community in Belmonte, told Paul and Dennis stories about his family. The two New Mexicans visited cities like Coimbra and Lisbon, Portugal, to see where their families came from. Before Portugal, Marez and Duran were in Israel at a meeting with Sephardic rabbis. The crypto-Jews of Belmonte are no longer hidden—they are now practicing Judaism openly.

Mr. Henriques, Paul Marez, and Dennis Duran, Belmonte, 1994

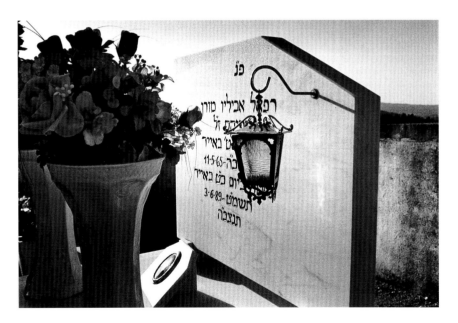

This headstone in Hebrew with an oil lamp, a symbol from the Old Jewish Temple in Jerusalem, was used on a grave stone dated 1989. This headstone has no Christian iconography.

Belmonte Catholic Cemetery

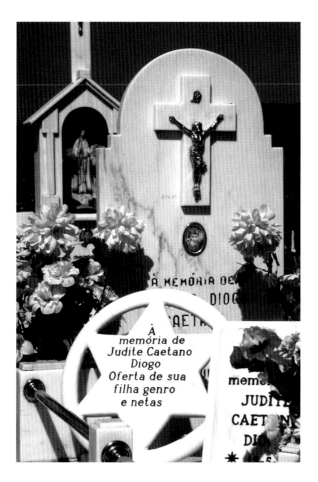

Old Catholic Cemetery, Belmonte, 1994

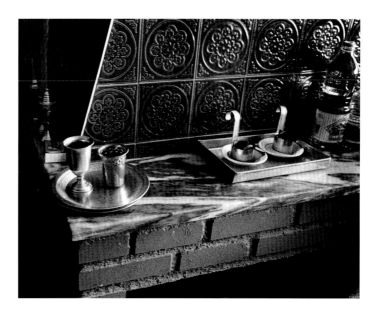

Shabbat, Belmonte, 1994

The descendants of the hidden Jews used an apartment for their Shabbat services. They had a kiddush cup and two handmade Shabbat oil lamps on the counter. Since my visit in 1994, the Belmonte Jewish community now has its own synagogue.

Judite Caetano Diogo's six-pointed star was an addition to the Catholic cross that had been the original grave marking.

Mezuzah indentation in stone, Guarda, Portugal, 1994

Inquisition marker, Guarda, Portugal, 1994

In 1994 Paul Marez and other Hispanic New Mexicans visited Guarda and Belmonte, Portugal, to attend a conference held by The Society for Crypto-Judaic Studies (SCJS). The above left photograph taken in the Guarda Jewish Quarter shows the indentation in the stone where a mezuzah (small case containing a scroll with biblical passages on it) was set. Mezuzot were removed from Jewish homes at the time of the Inquisition. In the bottom right photograph, Paul is touching an Inquisitional marker chiseled into the stone by the authorities. This left an indelible sign that this was a Jewish home. These symbols can be found on other homes in Portugal and Spain. Paul and others visited with the descendants of the hidden Jews of the border town of Belmonte. These families had always continued practicing their Jewish customs, like Friday night prayers, not eating pork, and making a form of matzah for the Passover.

Paul Marez, Guarda, Inquisition marker, 1994

The Old Jewish Quarter, Seville, Spain, 2000

Mrs. Chavez's *mezuzah*, 1995

FOUR

Cultural Collections

Objects, Folk Art, and Theatre

Objects

Herlinda Chavez, now deceased, kept a mezu-
zah on her kitchen wall. She lived on Taos Street in
Las Vegas, New Mexico. She had Catholic imagery
as well as a small Hanukkah menorah in her home.
She did not want to be photographed.

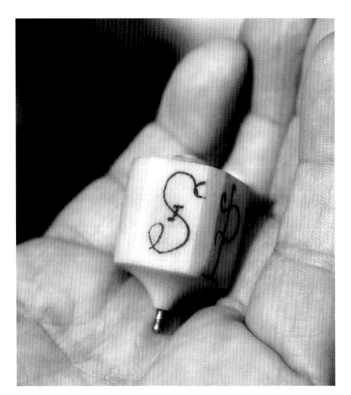

Pon y saca,
kosher knife,
and menorah,
Coca's collection,
2006

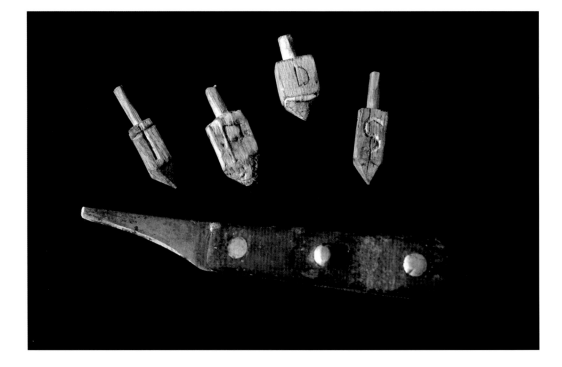

The trompito in Emilio Coca's hand was a toy he used to play Pon y Saca in December when he was a child in the 1930s. He learned the game from his grandfather, who carved the trompitos out of wood and Bakelite. The game is similar to the Jewish Hanukkah dreidel game where you spin the top and when it lands on a certain letter, you either put in, take out, pass, or take all, meaning whatever is in the pot. The pot could contain candy, chocolate, beans, or pennies.

> T = Todo (Take all)
> P = Pon (Put in)
> D = Deja (Leave there)
> S = Saca (Take out only as many as you have. So if you have three beans, you can only take three beans out of the pot.)

Coca's grandfather made and used the knife in the photograph for kosher slaughter of meat. He also made a Hanukkah menorah and two Shabbat candleholders out of cholla cactus.

Loggie Carrasco also spoke of Pon y Saca, though she called it "El Pon." She said, "We called the top 'Pon saca.' It is the same game as 'dreidel.' We played this game around Christmastime. We never called it a Christmas game, [and] we never thought that it was the dreidel game."

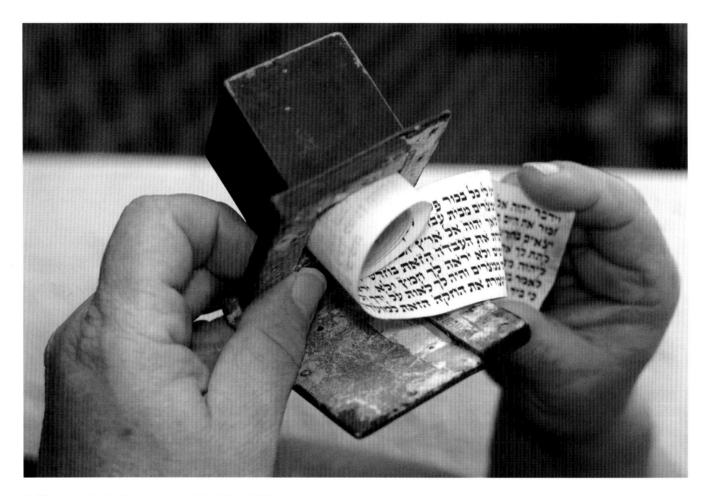

Tefillin from Rabbi Stephen Leon, B'nai Zion, El Paso, 2006

"I knew families in Juárez, [Mexico], who lit candles on Friday night. It was twenty years ago when it started for me. I am passionate about the Anusim community."

Rabbi Leon related a story told to him that explained how he was connected with the hidden Jewish community and why he was at B'nai Zion in El Paso. "An old Hispanic woman came to see me four years ago with her son and daughter-in-law. She told me the story of her grandfather, who had always wrapped an 'object' around his arm and head every morning. Her grandfather told her that his grandfather had done it as well. [Her grandfather] made her promise to bury one of these objects with him when he died and that when she died, she should bury the second one with her. She said she was really Catholic and wanted to give it to a Jewish minister [rabbi] to bury it with him. So now I, Rabbi Leon, will bury it with me when I die."

The object was a tefillin, something used by religious Jewish men, who wrap one around their forehead and the other around an arm and say morning prayers. How this woman found him, Rabbi Leon said, he did not know, but he felt that it was meant for him to have when he died.

Deuteronomy 6:8 says, "And you shall bind them upon your hand and they shall be for frontlets between your eyes." This woman fulfilled this commandment by giving her grandfather's tefillin to Rabbi Leon, thus ensuring its continuity in her secret Jewish family.

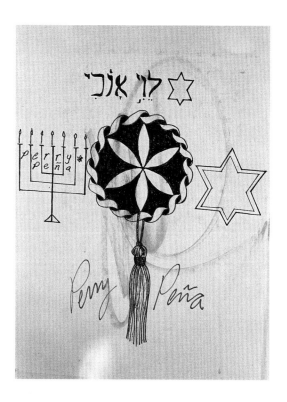

These drawings (left) appear on the inside of Perry's siddur (prayer book). He uses the motifs of six-pointed stars and a seven-branched candelabrum, representing the oldest symbols recalling the menorah of the Temple in Jerusalem. He wrote in Hebrew: "I am a Levite" (a member of the priestly tribe descended from Levi, one of the sons of Jacob/Israel). Perry's grandfather's hand-carved, wooden candle holder and spice box (bottom), etched with six-pointed stars, comprised his havdalah set, used to mark the end of the Shabbat.

Perry Peña's siddur and
havdalah set, 1994

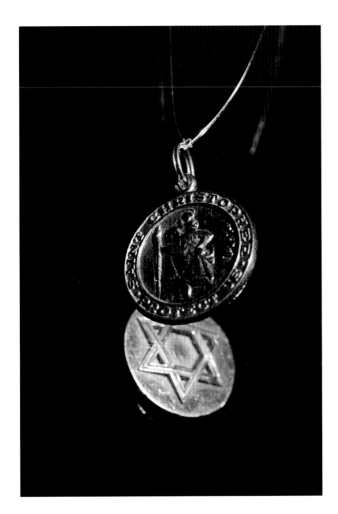

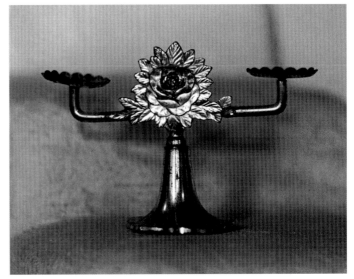

Grandmother's Shabbat, El Paso, Texas, 1993

❦ This is a grandmother's Shabbat
candle holder that the Henriquez
family showed me. ❦

St. Christopher pendant, 1994

❦ This St. Christopher medal with a Jewish
Mogen David on the back was found in
Albuquerque's South Valley. I photographed
this with a mirror so one can see both sides.
Who wore this dual-symbolic religious piece
of jewelry? ❦

Folk Art

Romero's cross, Santa Fe, 1994

This cross carved by Richard Romero has several symbols on it. It shows the six-pointed flower and a Jewish star in the center. Romero uses these symbols to connect him with the memory of his grandmother and her secret room where she went to pray in Truchas, New Mexico. "My art speaks for itself," he said.

Ruth, a six-pointed
star-shaped bulto, 1994

Marie Romero Cash, a New
Mexican *santera*, created this
"Ruth" bulto, made of tin and
wood and paint. According to
the Old Testament, Ruth was a
Moabite and the daughter-in-
law of Israelite Naomi, who lost
her husband and sons. She and
Naomi traveled together back
to Bethlehem. King David is a
descendant of Ruth.

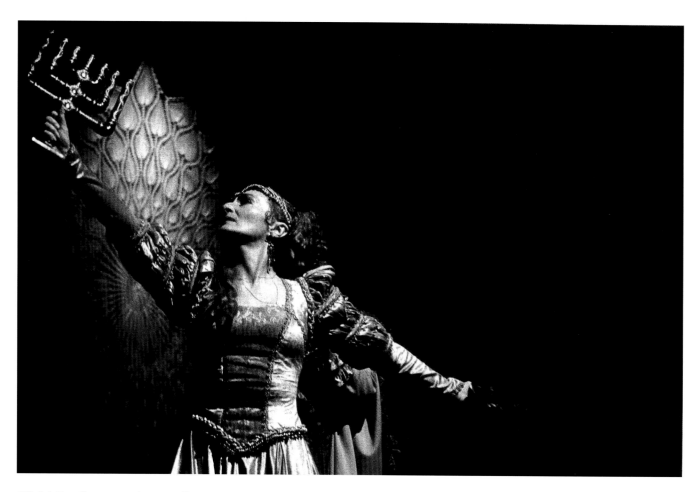

Lili del Castillo, KiMo Theatre, Albuquerque, March 9, 1997

Theatre

"My ancestors came from Toledo. Our family name was Alvarez [a place in Spain], which is also Moorish. My great uncle did research but could not find anything—he said if we were descendants of the Sephardics, it was very well hidden. From childhood I have always had an affinity for the Jewish culture. My belief showed in the program called *Revelaciónes*. It was about the revelation of a hidden Jew in the 1660s."

Revelaciónes was a drama portrayed through dance that described the story of a sixteenth-century Spanish woman whose parents had died in the plague. The story revolved around her discovery of a menorah in her mother's possession and her realization that the songs her mother had sung were not of Catholic origin but were actually Sephardic.

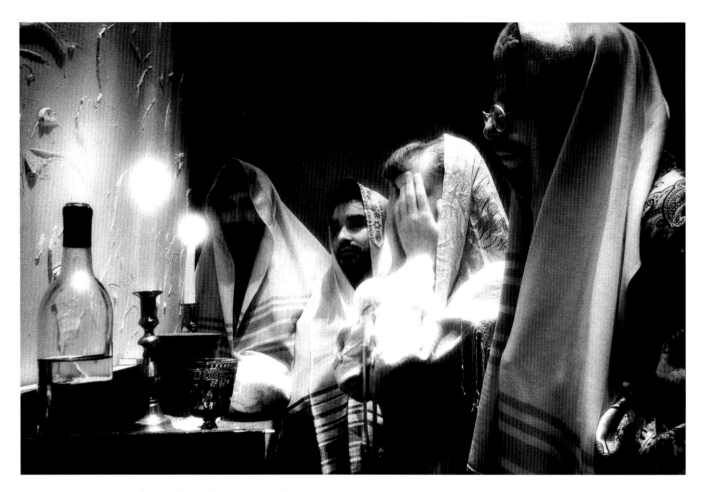

La Compañia presents *The Merchant of Santa Fe*, October, 1993

La Compañia de Teatro de Alburquerque presented *The Merchant of Santa Fe, A Story about the Hidden Jews of Colonial New Mexico* in 1993 at the KiMo Theatre in Albuquerque. It was a bilingual production by Lynn Butler and Ramón A. Flores.

The author's statement in the program said, "We wanted to make our Shylock, Don Saúl, true to his time, when to be openly Jewish was to invite the Inquisition, to ruin one's reputation, property, and life. Don Saúl embodies the tension between staying true to one's separate culture or faith and the desire to belong to the mainstream culture. We feel this a timely issue for our audience."

Don Saúl (left) and his daughter and other members of his family are at the secret Shabbat ritual, lighting candles and drinking the fruit of the vine.

A bronze engraving detail on the front door of the St. Francis Cathedral of La Conquistadora shows the statue being carried away from the fire at the cathedral in 1680

La Conquistadora:
A Crypto-Jewish Connection

Mona Hernandez

"La Conquistadora" was brought to Santa Fe, New Mexico, in 1625 by Fray Alonso Benavides, Custodian of the Franciscans[1] and representative of the Inquisition.[2] Francisco Gómez was the leader of the wagon train escort that brought Benavides and La Conquistadora.[3] A native of Portugal and orphaned at a young age, Gómez had been raised by an older half brother who was a Franciscan priest and a Commissary of the Holy Office.[4]

After arriving in New Mexico, Francisco Gómez established a successful military career and rose in the ranks very quickly, eventually becoming acting governor.[5] Gómez was seen as an outsider because of his Portuguese birth and was envied because of his rank and position. Informants claimed Gómez was observed preparing for the Sabbath on Fridays, didn't eat pork, and circumcised his sons.[6] In spite of his enemies' claims, Gómez and his wife helped establish a confraternity in honor of La Conquistadora, christened "Our Lady of the Rosary."[7] He had married Ana Robledo, an Española born in Yunque (San Juan), New Mexico. Research in the archives in Spain has revealed Ana Robledo's grandmother, Maria de Adeva, may have come from a family of suspected Jews.[8] Francisco Gómez and Ana Robledo

had several children born in Santa Fe, including Francisco Gómez Robledo, born in 1628, and Andres Gómez Robledo, born about 1640.

No action was ever taken against his father, but Francisco Gómez Robledo was not so fortunate. Also a military man, Gómez Robledo began his military career at the age of thirteen and rose in the ranks very quickly; he later served as councilman and municipal magistrate in Santa Fe.[9] In 1662 he held the rank of Sargento Mayor and served as mayordomo of Our Lady of the Rosary.[10] Like his father, he was accused of Judaizing (crypto-Jewish practices).[11] On May 4, 1662, at the age of thirty-four, Francisco Gómez Robledo was arrested in Santa Fe[12] and was later transported to Mexico City to stand trial before the Inquisition.[13] He would not be informed of the charges made against him for more than a year.[14] After his arrest, his brother-in-law Pedro Lucero de Godoy was designated to assist in the attachment of his property. Attached were his Santa Fe house, his encomiendas, and other properties.[15] The attachment was necessary to pay for his journey to Mexico City, his imprisonment, and his trial. All costs, including food and shackles, were the responsibility of the prisoner and paid out of the sale of his possessions. The Holy Office required three hundred pesos in security to cover Gómez Robledo's prison expenses.[16]

In April 1663 he was checked into the prison of the Holy Office in Mexico City.[17] Eighteen charges were brought against him, most for the crime of Judaizing or crypto-Jewish practices.[18] Although he was brought before the Inquisition tribunal several times, his actual trial did not begin until July 4, 1663.[19] Stanley Hordes's research of the Inquisition records in Mexico City revealed testimony given at Gómez Robledo's trial disclosing his brothers Juan and Andres Gómez Robledo were circumcised.[20] Two separate medical examinations performed by Inquisition surgeons discovered Francisco was also circumcised.[21]

Francisco explained this away, using as a part of his defense his father's long and loyal service to the crown[22] and his family's participation in Our Lady of the Rosary and their devotion to La Conquistadora.[23] This gave the appearance that the Gómez Robledo's were sincere Catholics. In spite of a convincing case of crypto-Judaism against Francisco Gómez Robledo, he was acquitted of all charges in 1664, and he eventually returned to Santa Fe.[24]

Why did the Gómez Robledo family help establish the confraternity? Though I prefer not to speculate on this since I have no way of knowing the actual reasons, a passage from *A History of the Marranos* offers an intriguing idea: "Victims of the Inquisition were revered as martyrs. In honor of certain outstanding figures, religious confraternities were formed, very much as though some Christian saint was in question."[25]

Nevertheless, the Pueblo Revolt in August 1680 forced the Spanish colonists out of New Mexico. Santa Fe was under siege by the Pueblo

Indians for ten days, the town, including its church, burned to the ground, but that didn't stop Josefa Lopez Grijalva Sambrano, niece of Francisco Gómez Robledo, from entering the church and rescuing La Conquistadora.[26] Knowing the danger, why would Josefa risk her life? Why was it so important to save La Conquistadora? *A History of the Marranos* states, "The conversos formed religious associations with Catholic objects and under the patronage of some Christian saint used this as a cover for observing their ancestral rites."[27]

The Spanish Recolonization of 1693

Only four members of the Gómez Robledo family returned to New Mexico in 1693; they were the nieces of Francisco Gómez Robledo and the daughters of Andres Gómez Robledo. Andres had been killed in the Pueblo Revolt in 1680 and was survived by his widow Juana Ortiz and four daughters: Francisca, Lucia, Margarita, and Maria. Francisca Gómez Robledo, daughter of Andres and Juana, married Ignacio Roybal, a soldier and a native of Galicia, Spain, in Santa Fe on February 8, 1694.[28] There were many new families settling in New Mexico, families that had been recruited in Mexico City. Arriving in 1694 were the Vega y Coca, Ortiz, and Sena families.[29] In 1750, Michaela Roybal, possible granddaughter of Ignacio Roybal and Francisca Gómez Robledo, married Juan Coca in Santa Fe.[30] My mother Mae Coca and I directly descend from this couple.

Our Lady of the Rosary's Members and Their Relationship to the Founders

Some of Our Lady of the Rosary's members before and after the Pueblo Revolt were blood related or had married into the Gómez Robledo family. They were the Gómez Robledos and their immediate family, including Francisco Lucero de Godoy, nephew of Francisco Gómez Robledo and husband of Josefa Lopez Grijalva Sambrano. After the reconquest, members included Santiago Roybal, New Mexico's first secular priest,[31] and his brother Mateo Roybal, both sons of Ignacio Roybal and Francisca Gómez Robledo. In addition, Bernardo Bustamante, a native of Santander, Spain, and his wife Feliciana Coca were contributors.[32] Bernardino Sena, an orphan born in Mexico City, arrived in New Mexico at the age of nine in 1694. In 1727 he married his second wife, Manuela Roybal, daughter of Ignacio Roybal and Francisca Gómez Robledo, in Santa Fe.[33] Sena was in charge of Our Lady of the Rosary for forty-eight years, from 1717 until his death in 1765.[34] During the 1760 to 1770 time period, membership and interest in Our Lady of the Rosary diminished. Why? Perhaps Sena was its leader for too long.

Revival of Our Lady of the Rosary, 1770

On August 31, 1769, a prominent citizen and distinguished soldier, Nicolas Ortiz III, was killed by the Comanches in Abiquiu, New Mexico.[35] When Governor Pedro Fermin de

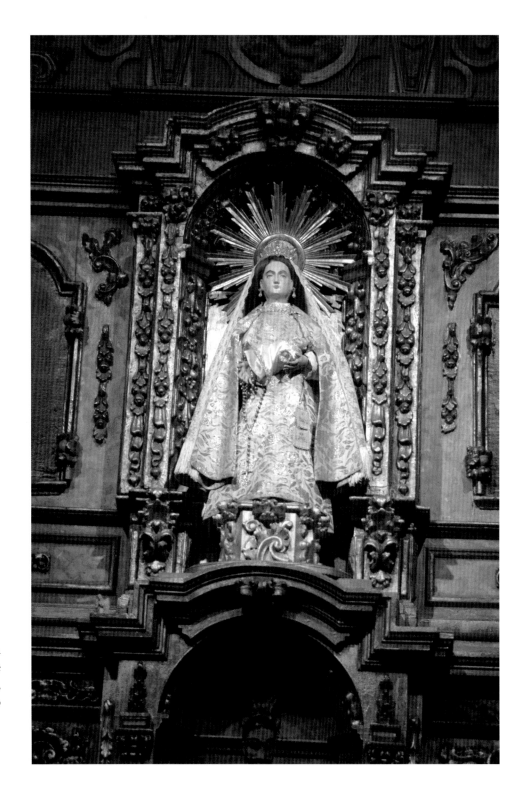

La Conquistadora
in her chapel in the
cathedral, Santa Fe,
New Mexico

Mendinueta called upon Ortiz's widow and second wife, Josefa Bustamante, daughter of Bernardo Bustamante and Feliciana Coca, to offer his condolences, Josefa sadly remarked that such evils happened because there was no patron saint.[36] Ortiz's death and the Comanche raids that had plagued New Mexico from the years 1768 to 1778 set in motion the revival of Our Lady of the Rosary, and La Conquistadora was declared patron saint in 1770. In the same year a celebration was held in honor of Our Lady of the Rosary and La Conquistadora, and by 1776 the celebration had become a three-day affair.[37] La Conquistadora had been given a new purpose, which was for intercession to protect New Mexico from further Indian attack.

But was Ortiz's death the only reason for the revival of Our Lady of the Rosary? In 1730 Nicolas Ortiz III married his first wife Gertrudis Paez Hurtado in Santa Fe.[38] Their marriage witnesses were Diego Arias and his wife Maria Gómez Robledo, daughter of Andres Gómez Robledo and Juana Ortiz. Were Nicolas Ortiz III and Juana Ortiz related? It is not known. Prior to the death of Nicolas Ortiz III, no one from the Ortiz family participated in Our Lady of the Rosary, except Ortiz's former father-in-law, General Juan Paez Hurtado, who was one of its early leaders.[39] Diego Arias was also a member.

Our Lady of the Rosary Today

The St. Francis Cathedral stands on the historic Santa Fe plaza. On the front door of the church panels depict various periods in New Mexico's history, including the arrival of La Conquistadora in 1625 and the Pueblo Indian Revolt in 1680, when La Conquistadora was carried out of Santa Fe. This church is the home of La Conquistadora. The former home of Nicolas Ortiz III is also on the Santa Fe plaza, located on West San Francisco Street. The Historic Santa Fe Foundation declared Ortiz's home a historical monument. The former home of Ignacio Roybal and Francisca Gómez Robledo is located in the Pojoaque Valley in Jacona, New Mexico. This home was built on land that Roybal received around 1705 and is where the couple raised their nine children. Roybal was one of New Mexico's leading citizens; he held municipal offices in Santa Fe and served as High Sheriff of the Inquisition.[40] Positions in the government and in the church were commonplace for conversos and crypto-Jews.

La Conquistadora holds a special meaning for me because she is what remains of the Gómez Robledos, Josefa Lopez Grijalva Sambrano, Bernardino Sena, Nicolas Ortiz III, Josefa Bustamante, and all my ancestors who were members and contributors of her confraternity, Our Lady of the Rosary, and who played a part in much of New Mexico's history. La Conquistadora's connection to the history of crypto-Judaism in New Mexico can be traced to the seventeenth-century Portuguese Gómez Robledo family, whose efforts have made the statue forever famous in New Mexico.[41]

NOTES

1. Stanley Hordes, *To The End of the Earth: A History of the Crypto-Jews of New Mexico* (New York: Columbia University Press, 2005), 139.

2. Fray Angélico Chávez, *Origins of New Mexico Families: A Genealogy of the Spanish Colonial Period*, rev. ed. (Santa Fe: Museum of New Mexico Press, 1992), 112.

3. La Conquistadora has been described as the "oldest representation of the Virgin Mary" in the United States. She is better known as the "Patroness" of New Mexico.

4. Chávez, *Origins of New Mexico Families*, 35; Fray Angélico Chávez, *La Conquistadora: An Autobiography of an Ancient Statue*, rev. ed. (Santa Fe: Sunstone Press, Santa Fe, 1983), 21.

5. Chávez, *Origins of New Mexico Families*, 35. In 1641 Governor Flores, on his deathbed, appointed Francisco Gómez as interim governor, but he was not accepted by the council of native New Mexicans.

6. Pat Tsoodle, "Crypto Judaism: Rio Arriba's Hidden Influence?" *Salsa: A Monthly Supplement to the Rio Grande Sun* [Española, NM], July 7, 1988, D-10; Chávez, *La Conquistadora*, 29. Rumors were spread that Gómez not only had Jewish blood, but also practiced Judaism in secret, circumcising his sons and saying prayers on Friday while wearing a cap inside the house (Hordes, *To the End of the Earth*, 158). The testimony of New Mexicans Juan Griego, Antonio Lopez Zambrano, Domingo Lopez de Ocanto, Fray Garcia de San Francisco, and Diego Romero makes it clear that the Jewish identity of the Gómez family was suspected throughout the province, not only at the time of Gómez Robledo's arrest in 1662, but also in previous decades. The witnesses testifying against Francisco Gómez Robledo insisted that it was common knowledge in the colony that his father Francisco Gómez was a Jew.

7. Chávez, *La Conquistadora*, 31; Chávez, *Origins of New Mexico Families*, 35.

8. Hordes, *To the End of the Earth*, 114. Maria de Adeva may have been related to the Benadeva family of the late fifteenth century who were persecuted by the Inquisition and eventually fled Seville.

9. John L. Kessell, *Kiva, Cross and Crown: The Pecos Indians and New Mexico 1540–1840* (Washington, D.C.: National Park Service, U.S. Department of the Interior, 1979), 186.

10. Ibid.

11. Hordes, *To the End of the Earth*, 6. The Inquisition referred to the conversos and their descendants who engaged in secret practice of Judaism as "Judaizers," crypto, or secret, Jews.

12. Kessell, *Kiva, Cross and Crown*, 185.

13. Hordes, *To the End of the Earth*, 153.

14. Kessell, *Kiva, Cross and Crown*, 185.

15. Ibid.

16. Ibid., 191.

17. Ibid.

18. Harriet and Fred Rochlin, *Pioneer Jews: A New Life in the Far West* (Boston: Houghton Mifflin Company, 1984), 9.

19. Hordes, *To the End of the Earth*, 157. According to Hordes, Gómez Robledo's first audience with the inquisitors in Mexico City took place

on July 4, 1663. However, *Pioneer Jews* gives the date as May 16, 1663 (Rochlin 9).

20. Hordes, *To the End of the Earth*, 159 (testimony of Domingo Lopez de Ocanto).

21. Ibid., 159–60. Three Inquisition surgeons found scars on the penis of Francisco Gómez Robledo, which appear to have been made by a sharp instrument.

22. Kessell, *Kiva, Cross and Crown*, 192.

23. Chávez, *La Conquistadora*, 38.

24. Hordes, *To the End of the Earth*, 162. Despite the strength of the testimony against Francisco Gómez Robledo, combined with the confirmation of his circumcision, he was absolved of all charges of Judaism. Chávez, *Origins of New Mexico Families*, 36. In 1680 Francisco Gómez Robledo was married, had a grown son Antonio, two small sons, and five daughters. It is not known who they were or if they returned to New Mexico. Antonio was mentioned in 1663 during his father's Inquisition trial (Archivo Historico de Parral, AHP 1715A, frame 45 and AHP 1723A, frame 378, San Felipe y Santiago de Janos presidio rosters). I found two men of interest stationed at the Janos presidio in Nueva Viscaya, Chihuahua, Nueva España (present-day northern Chihuahua, Mexico) in 1715 and 1723. Lieutenant Francisco Ignacio Gómez Robledo, a native of New Mexico, enlisted on December 15, 1688, and Ensign Joseph Gómez, also a native of New Mexico, enlisted on March 20, 1704. The 1715 roster identifies both men as the sons of maese del campo Francisco Gómez Robledo. This was Francisco's title when he passed muster in 1680. Sylvia Fernandez Magdaleno's research of the Mexican records made it possible for me to locate the sons of Francisco Gómez Robledo, and she provided copies of the presidio rosters. Microfilm of the presidio rosters is available at the following colleges: University of California–Riverside, California State University–Northridge, and University of Texas–El Paso.

25. Cecil Roth, *A History of the Marranos*, 5th ed. (New York: Sepher-Hermon Press, 1992), 20, 171.

26. Chávez, *Origins of New Mexico Families*, 60. Josefa Lopez Grijalva Sambrano's daughter testified that it was her mother who took La Conquistadora when the colonists fled New Mexico in 1680.

27. Roth, *The History of the Marranos*, 20, 171. Again, I prefer not to speculate, but since the family associated with La Conquistadora appears to have been insincere Catholics based on Inquisition trial records, it seems odd that a member of the Gómez Robledo family would risk her life to save the statue from destruction. However, I wonder if there could have been other reasons why La Conquistadora was saved. Hordes, *To the End of the Earth*, 5. According to Hordes, there are two subsets within the term "converso": those who converted sincerely and those who converted in name only and secretly continued to practice their ancestral Jewish religion. Scholars refer to the latter as "crypto-Jews."

28. Fray Angélico Chávez, "New Mexico Roots, Ltd: A demographic perspective from

genealogical, historical, and geographical data found in the *Diligencias Matrimoniales*, or Pre-Nuptial Investigations (1678–1869) of the Archives of the Archdiocese of Santa Fe" (Santa Fe: 1982) [hereafter DM], 1694, no. 1, and 1695, no. 3, Santa Fe.

29. The Spanish Archives of New Mexico II (SANM II), New Mexico Records and Archives Center, Santa Fe, no. 54c.

30. Santa Fe New Mexico Marriages: June 14, 1750, LDS #0016905, Los Angeles Family History Center Library; Mona Hernandez, Eduardo Morga, and Gloria Trujillo, "Vega y Coca/de la Vega/Laso de la Vega y Vique/Coca 1693–1800," *Herencia: The Quarterly Journal of the Hispanic Genealogical Research Center of New Mexico* 12, No. 1 (2004): 2–16. Although there is no documentation positively linking Michaela Roybal to the Roybal family, extensive genealogical research indicates the likelihood that she was a granddaughter of Ignacio Roybal and Francisca Gómez Robledo.

31. "Secular" priest refers to someone "not belonging to a religious order; not bound by monastic vows" (*Random House Webster's College Dictionary*).

32. Fray Angélico Chávez and Eleanor B. Adams, *The Missions of New Mexico, 1776: A Description by Fray Francisco Atanasio Dominguez* (Albuquerque: University of New Mexico Press, 1956), 17. This book lists all confraternity members.

33. Chávez, DM: 1727, no. 11, May 13, Santa Fe.

34. Chávez, *La Conquistadora*, 67.

35. Santa Fe New Mexico Deaths: September 4, 1769, LDS #0016906, Los Angeles Family History Center Library, Santa Monica, California.

36. Historic Santa Fe Foundation, *Old Santa Fe Today*, 3rd ed. (Albuquerque: University of New Mexico Press, 1982), 24.

37. Ibid., 25.

38. Santa Fe New Mexico Marriages: May 28, 1730, LDS #0016905, Los Angeles Family History Center Library.

39. Chávez, *La Conquistadora*, 65.

40. Historic Santa Fe Foundation, *Old Santa Fe Today*, 93.

41. Chávez, *Origins of New Mexico Families*, 35.

Anusim. A Hebrew word meaning "the forced ones" or "the compelled ones." Many descendants of the Spanish and Portuguese who were forced to convert to Catholicism refer to themselves as Anusim.

Adonai (Adonay). Hebrew name for God.

Bulto. Statue of a saint carved out of wood.

Camposanto. Cemetery; burial ground.

Circumcision. A Jewish religious rite, referring to the cutting of the foreskin on Jewish male children on the eighth day after birth. It was used by the Inquisition to identify Jewish men.

Converso. Means convert; a Jew who publicly recanted his or her faith and adopted Christianity under the pressure of the Spanish Inquisition. Scholars have also used this term to refer to the descendants of conversos as well.

Crypto-Jew. Word used to describe a descendant of conversos who secretly practiced (or practices) Judaism while outwardly professing another religion such as Catholicism.

Day of Atonement. Yom Kippur, the Jewish Day of Atonement celebrated in the fall. One fasts and prays for the whole day.

Dreidel. A four-sided die that revolves like a spinning top and is marked on each side with a different Hebrew letter; used as a toy especially during the Hanukkah festival.

Encomiendas. Estate granted to Spanish settlers in colonial America.

Esposo. Spanish for husband.

Havdalah (Habdalah). A Jewish ceremony that marks the end of the Sabbath or other holy days. On completion of the Sabbath, a candle with more than one wick is used, along with spices and wine to commemorate the departure of the day.

Hermano. Spanish for "brother"; used by the Penitentes to mean a member of their religious group or brotherhood.

Judaizer. Word used to describe a Christian who practiced the "Law of Moses" in secret. People who were charged with Judaizing by the Inquisition authority were taken to trial.

Kaddish. An ancient Jewish prayer in Aramaic recited in several forms by the cantor in the daily ritual of the synagogue and adopted for use on various occasions; the term "Kaddish" is often used to refer specifically to "The Mourners' Kaddish," said as part of the mourning ritual in Judaism.

Kohanim (Cohanim). Plural for Cohen or Kohen, a member of one of the families or clans descended from the high priest Aaron having certain hereditary religious privileges and responsibilities.

Ladino. An archaic form of the Spanish language that encompasses Spanish, Hebrew, Greek, and other languages. Ladino is still spoken by Sephardic Jews around the world.

Magen (Mogen) David. A six-pointed Jewish star; the Star of David.

Marrano. Literally means "pig" in Spanish; this derogatory term originated from the Arabic word "muharram," meaning "ritually forbidden," and was used to designate a Christianized Jew or Moor of medieval Spain, especially one who accepted conversion only to escape persecution.

Matzah (Matza; Matzo). Unleavened bread eaten at the Passover.

Mezuzah (pl. Mezuzot). A piece of parchment inscribed on one side with the scriptural passages Deut 6:4–9 and 11:13–21 written in twenty-two lines and on the other with the name Shaddai (a name for God), rolled up in a scroll, and placed in a small wooden, metal, or glass case or tube that is affixed to the doorpost of some Jewish homes as a symbol of Jewishness.

Mi Seferino. Means "my little prayer book," perhaps originating from the Hebrew word *Sefarad* that over time has come to mean Spain. It also is a name given to children, Seferino and Seferina.

Mitzvah. An act of kindness performed by a Jewish person; a Jewish religious duty or obligation, especially one of the commandments of Jewish religious law.

Mohel. Someone who is qualified under Jewish religious law to carry out circumcisions.

Morada. A dwelling.

Patriarch. An ancestor or religious leader of the Hebrew people from the Jewish Bible, specifically Abraham, Isaac, and Jacob.

Pentateuch. The first five books of the Hebrew Bible: Genesis, Exodus, Leviticus, Numbers, Deuteronomy; also referred to as the Torah.

Pon y Saca. A game of chance played with a

top (*trompito*) by children and adults. *Pon* (P) means put in, *Saca* (S) means take out, *Todo* (T) means to take all, and *Deja* (D) means to leave there. Also used as a term for the top itself. See *Dreidel*.

Sanbenito (Sambenito). A Spanish Inquisition garment resembling a scapular either of yellow with red crosses for the penitent or of black with painted devils and flames for the impenitent condemned to a sentence of judgment.

Santos. Saints.

Sephardic Jews. Members of the occidental branch of European Jews settling early in Spain and Portugal and later spreading to Greece, the Levant, England, the Netherlands, and the Americas.

Shin. The twenty-first letter in the Hebrew alphabet. In Hebrew the letter stands for *Shaddai*, meaning "Almighty God."

Siddur. A Jewish daily prayer book.

Sudario. Spanish word for shroud. For crypto-Jews, it can also mean a prayer for the peace of the soul for a dead person prayed at wakes that is very similar to the Jewish Kaddish.

Tallit (Tallith). A fringed prayer shawl with four corners traditionally worn only by Jewish men during the morning prayers, Torah services, and on the eve of Yom Kippur. The twined and knotted fringes are known as *tzitit*.

Tanakh (Tanach). An acronym that identifies the Hebrew Bible. It is based on the initial Hebrew letters of each of the text's three parts: "T" for Torah (first five books, see *Pentateuch*), "N" for *Nevi'im* (Prophets), and "KH" for *Khatuvim* ("Writings," including Psalms, Proverbs, and Books of Job, Esther, etc.).

Tefillin. Phylacteries, or small boxes, with biblical verses in them, worn on the arm and forehead during prayers.

Tikkun. Literal Hebrew meaning is "repair" or, in its expanded form, mending the world.

Trompito. Toy top used to play *Pon y Saca*.

T'shuvah. Return; used to describe the process of repentance.

Tzedakah. Means justice and charity. Judaism is very tied to this concept. Because Judaism puts emphasis on doing good deeds, one's acts of righteousness are extremely important in living a sacred life.

Tzitit. Tiny-knotted fringes made of a special twine that hang from the *tallit* that is worn for prayer. Very observant men also wear them under clothing.

Virgin of Guadalupe (Our Lady of Guadalupe). The patron saint of Mexico in the Roman Catholic Church.

Yarmulke. Small, round skullcap worn by Jewish men and boys. Observant Jews wear it all the time. Also known as a *kippah*.

BIBLIOGRAPHY

Archives and Public Records

Archivo Historico de Parral, AHP 1715A, frame 45 and AHP 1723A, frame 378: San Felipe y Santiago de Janos Presidio Rosters, lists of soldiers stationed at the Janos Presidio, Chihuahua, Mexico. This microfilm is at the following colleges: University of California–Riverside, California State University–Northridge, and University of Texas–El Paso.

Santa Fe New Mexico Deaths, LDS #0016906, Los Angeles Family History Center Library

Santa Fe New Mexico Marriages, LDS #0016905, Los Angeles Family History Center Library

The Spanish Archives of New Mexico I and II, New Mexico Records and Archives Center, Santa Fe

Books and Articles

Alcalá, Kathleen. *Spirits of the Ordinary: A Tale of Casa Grande*. New York: Harcourt Brace & Company, 1997.

———. *The Desert Remembers My Name: On Family and Writing*. Tucson: University of Arizona Press, 2007.

Atencio, Tomás. "Crypto-Jewish Remnants in Manito Society and Culture." *Jewish Folklore and Ethnology Review* 18 (1996): 59–68.

———. "The Converso Legacy in New Mexico Hispano Protestantism." *El Caminante* 2 (2003): 10–15.

Atencio, Tomás, and Stanley M. Hordes. *The Sephardic Legacy in New Mexico: A Prospectus*. University of New Mexico, Southwest Hispanic Research Institute, 1987.

Baer, Yitzhak. *A History of the Jews in Christian Spain*. 2 vols. Philadelphia: Jewish Publication Society of America, 1971.

Canelo, David Augusto. *The Last Crypto-Jews of Portugal*. Portland, Oregon: Institute for Judaic Studies, 1990.

Chávez, Fray Angélico. *La Conquistadora: An Autobiography of an Ancient Statue*. Rev. ed. Santa Fe: Sunstone Press, 1983.

———. *My Penitente Land: Reflections of Spanish New Mexico*. Albuquerque: University of New Mexico Press, 1954.

———. "New Mexico Roots Ltd.; A Demographic Perspective from Genealogical, Historical, and Geographical Data Found in the Diligencias

Matrimoniales or Pre-nuptial Investigations (1678–1869) of the Archives of the Archdiocese of Santa Fe." Santa Fe, New Mexico: Archdiocese of Santa Fe, 1982.

———. *Origins of New Mexico Families: A Genealogy of the Spanish Colonial Period*. Rev. ed. Santa Fe: Museum of New Mexico Press, 1992.

Chávez, Fray Angélico, and Eleanor B. Adams. *The Missions of New Mexico, 1776: A Description by Fray Francisco Atanasio Dominguez*. Albuquerque: University of New Mexico Press, 1956.

Cohen, Martin. *The Martyr: Luis de Carvajal, A Secret Jew in Sixteenth Century Mexico*. Philadelphia: Jewish Publication Society of America, 1973.

Ferry, Barbara and Debbie Nathan. "Mistaken Identity? The Case of New Mexico's 'Hidden Jews,'" *Atlantic Monthly*, December 2000.

Gerber, Jane S. *The Jews of Spain: A History of the Sephardic Experience*. New York: The Free Press, 1992.

Gitlitz, David. *Secrecy and Deceit: The Religion of the Crypto-Jews*. Philadelphia: Jewish Publication Society of American, 1996.

Greenleaf, Richard. *The Mexican Inquisition of the Sixteenth Century*. Albuquerque: University of New Mexico Press, 1969.

Halevy, Schulamith. "Manifestations of Crypto-Judaism in the American Southwest." *Jewish Folklore and Ethnology Review* 18 (1996): 68–76.

Hernandez, Mona, Eduardo Morga, and Gloria Trujillo. "Vega y Coca/de la Vega/Laso de la Vega y Vique/Coca 1693–1800." *Herencia: The Quarterly Journal of the Hispanic Genealogical Research Center of New Mexico* 12, no. 1 (2004): 2–16.

Historic Santa Fe Foundation. *Old Santa Fe Today*.

3rd ed. Albuquerque: University of New Mexico Press, 1982.

Hordes, Stanley M. "The Sephardic Legacy in New Mexico: A History of the Crypto-Jews." *Journal of the West* 35, no. 4 (1996): 82–90.

———. *To the End of the Earth: A History of the Crypto-Jews of New Mexico*. New York: Columbia University Press, 2005.

Jacobs, Janet Liebman. *Hidden Heritage: The Legacy of the Crypto-Jews*. Berkeley: University of California Press, 2002.

Kessell, John L. *Kiva, Cross and Crown: The Pecos Indians and New Mexico 1540–1840*. Washington, D.C.: National Park Service, U.S. Department of the Interior, 1979.

Kunin, Seth. "Juggling Identities Among the Crypto-Jews of the American Southwest." *Religion* 31 (2001): 41–61.

Liebman, Seymour. *The Enlightened: The Writing of Luis Carvajal El Moro*. Coral Gables, Florida: University of Miami Press, 1970.

Moya, Emma. "New Mexico's Sephardim: Uncovering Jewish Roots." *La Herencia del Norte* (Santa Fe, New Mexico) 12 (1996): 9–13.

———. "New Mexico's Sephardim: Uncovering Jewish Roots." *La Herencia del Norte* (Santa Fe, New Mexico), 16 (1998): 64–65.

———. "New Mexico's Sephardim: Uncovering Jewish Roots." *La Herencia del Norte* (Santa Fe, New Mexico) 26 (2000): 56.

———. "New Mexico's Sephardim: Uncovering Jewish Roots." *La Herencia del Norte* (Santa Fe, New Mexico), 32 (2001): 56.

Neulander, Judith. "Crypto Jews of the Southwest: An Imagined Community." *Jewish Folklore and Ethnology Review* 16 (1994): 64–68.

Peña, Perry. *Beyond Crypto-Judaism: An Historic Profile of an Anusim's Journey in New Mexico.* Albuquerque: Lulu, 2006.

Perera, Victor. *The Cross and the Pear Tree: A Sephardic Journey.* New York: Alfred A. Knopf, 1995.

Rochlin, Harriet, and Fred Rochlin, *Pioneer Jews.* Boston: Houghton Mifflin Company, 1984.

Roth, Cecil. *A History of the Marranos.* 5th ed. New York: Sepher-Hermon Press, 1992.

Santos, Richard G. *Silent Heritage: The Sephardim and the Colonization of the Spanish North American Frontier, 1492–1600.* San Antonio: New Sepharad Press, 2000.

Telstch, Kathleen. "Scholars and Descendants Uncover Hidden Legacy of Jews in the Southwest." *New York Times*, November 11, 1990, 16.

———. "After 500 Years, Discovering Jewish ties that Bind." *New York Times*, November 29, 1992, 28.

Tsoodle, Pat. "Crypto Judaism: Rio Arriba's Hidden Influence?" *Salsa: A Monthly Supplement to the Rio Grande Sun* [Española, NM], July 7, 1988.

Internet

http://www.cryptojews.com (Society for Crypto-Judaic Studies)

http://www.herencia.com (*La Herencia Magazine*)

http://www.jewishencyclopedia.com

http://www.saudades.org (Portuguese Sephardic History)

http://www.somosjudios.org (B'nai Sephardim of the Southwest)